How To
Photograph

Insects
& Spiders

How To Photograph

Insects & Spiders

Larry West
with Julie Ridl

STACKPOLE
BOOKS

Published by
STACKPOLE BOOKS
5067 Ritter Road
Mechanicsburg, PA 17055

Printed in Hong Kong

10 9 8 7 6 5 4 3 2 1

First edition

Cover design by Tracy Patterson with Kathleen Peters

Library of Congress Cataloging-in-Publication Data

West, Larry.
 How to photograph insects and spiders / Larry West with Julie
Ridl. — 1st ed.
 p. cm.
 Includes bibliographical references.
 ISBN 0-8117-2453-0
 1. Photography of insects. I. Ridl, Julie. II: Title.
TR729.I6W47 1994
778.9'32—dc20 93-42993
 CIP

For Mike Kirk, my longtime friend, whose innovative designs make my endeavors much easier and a lot more fun.

For Meridith "Bug" Ridl.

And for all our readers who hold a deep respect for Earth's other inhabitants and care enough about the land to walk gently upon it.

CONTENTS

*Fallen petals rise
back to the branch—I watch:
oh . . . butterflies!*

—Moritake

PREFACE

We're pleased to present *How to Photograph Insects and Spiders.* This volume, a year in the making for me, a lifetime in the making for Larry, is overdue for its audience—the many friends and students Larry has met in his thirty-five-year career as a photographer of small creatures.

Larry has spent a lifetime innovating in both his technology and his art. The book you're holding includes photographic techniques he's used for decades, along with some he developed during the summer of 1993, as we were finishing the manuscript.

We present the information here in an order that seems to make sense to us. The art of photography is learned through overlapping revelations, not linear study. To create good photographs takes patience, and beginners should learn to be extremely patient with themselves. It's only after you've studied the book and start to apply the techniques in the field that things begin to click. What you know about the technology of photographics must become almost instinctive so you can free yourself in the field to understand and see your subjects.

This idea of working through the technology back into your instincts and love of the subject is absolutely essential to us. It is why we write books like this one. We try to demonstrate the idea through portfolio sections like "Wee Folk," an armchair photography experience in the field with Larry.

This book would never have seen a printing press without the help, time, advice, expertise, and support of our friends and family, notably Mike Kirk, Mike Rigsby, Nora Deans, Bonnie West and Jack Ridl.

<div align="right">J.R.</div>

A Fine Experience,
a Fine Photograph

Out of the corner of your eye, you see a sprinkling of small, dark specks on the surface of the snow. Your subconscious processes the scene: pepper. Someone has peppered the snow.

If you're busy, moving as humans do from one place to another—quickly, not fully registering all you see—the sight of pepper on the snow will not stop you. Will not delight you. Will not cause you to marvel or bring humility and awe.

(Top) 200mm macro lens with 4T close-up, TTL electronic flash, camera compensation dial set at +2.7, 50-speed film, 1/250 sec., f/22, hand-held.
(Bottom) 200mm macro lens with two 4T close-up lenses, PN-11 and PK-13 extension tubes, a TC-301 multiplier, TTL electronic flash, camera compensation dial set at +2.7, 50-speed film, 1/250 sec., f/16, on a board pod.
(Achorutes nivicolus)
One of the most primitive insects, the snow flea (3X life-size, top, and close-up, bottom) is a springtail (order Collembola), meaning it can hurl itself many times its body length across the snow by use of its furcula, *seen in the close-up photo. The furcula is a special leaping organ that folds under the flea and is held by a catch. When the snow flea releases the catch, it catapults forward.*

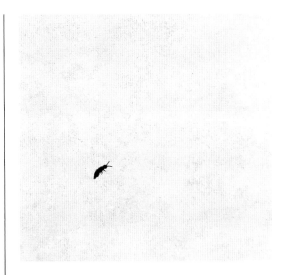

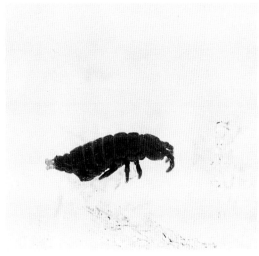

If, however, you are like me, the pepper on the snow will send you running back into the house for woolen socks and mittens, waterproof coat and pants, camera equipment, film, and a perfect willingness to spend the next hour or two lying facedown in the cold. All this to record the presence of one of the most primitive insect forms in the living world, the snow flea *(Achorutes nivicola)*. The snow flea is a springtail, a cousin to the oldest known insect, another springtail that dates to the middle Devonian period, about 350 million years ago.

Springtails, mantids, butterflies, and spiders. Wasps, moths, grasshoppers, ants. Ticks, scorpions, flies. Caterpillars and other larvae. Aphids, fleas, beetles. Treehoppers, bees, weevils, and dragonflies. When you fall in love with insects and their kin, you're siding with the majority.

Humans have identified and given name to more than a million kinds of insects, approximately a third of the estimated 3 million insect species in the world. This is many, many more species of life than in all the other plant and animal groups combined. They are fabulously varied, marvelously adapted, dramatically wrought. Some of these species, like the snow flea, have inhabited the earth for millions of years—far longer than humans and their recognizable ancestors. And we are only just beginning to know them.

This marvelous world, this limitless scope of color, beauty, and drama, has long appealed to nature photographers. Insects are often beautiful, always fascinating. Insects are everywhere, all the time. Insects make satisfying subjects for the nature photographer because they're technically challenging, fairly easy to approach, and can provide a lifetime of discovery. I've spent days and weeks crawling back and forth along a fallen log photographing creatures that have yet to receive common names. I love them for their difference. They allow me to explore a world quite apart from mine, while they remain, for the most part, unaware of my existence, except when I offer a place to perch or provide a source of food.

Art Through Technology

During the past thirty-something years, I've taught thousands of students the art of nature photography. People from all walks of life, young and old, have come to my workshops knowing only that they've found something out there they want to explore and record on film.

What these diverse workshop students are experiencing, in part, is a reawakening of the hunting-gathering instinct. This instinct is central to human experience. Through nature photography, my workshop students and I find we satisfy this instinct without harming the environment, by hunting and gathering photographs instead of animals or plants—by collecting insect photographs instead of insects.

Photography is a wonderful merging of art and science. Seeing, putting yourself in the right place, perceiving the possibilities of a photographic moment, then applying the very sequential, very ordered technology—the right mix of light, film, lens, and exposure to get precisely the image you have in mind—this is the discipline of nature photography.

I can offer no easy, five-step description of how to take a beautiful photograph. Beautiful

200mm macro lens with 1.4X multiplier, TTL electronic flash, flash compensation dial set at −2.0, 50-speed film, 1/4 sec., f/11, on tripod.
(Anax junius)
Backlit by the rising sun, this image of the shed naiad of a green darner speaks volumes about the intricate structure of insects. Capturing the effect of this dramatic light would have been difficult without use of fill flash technology, which gives color and detail to the skin without overpowering the light shining through it.

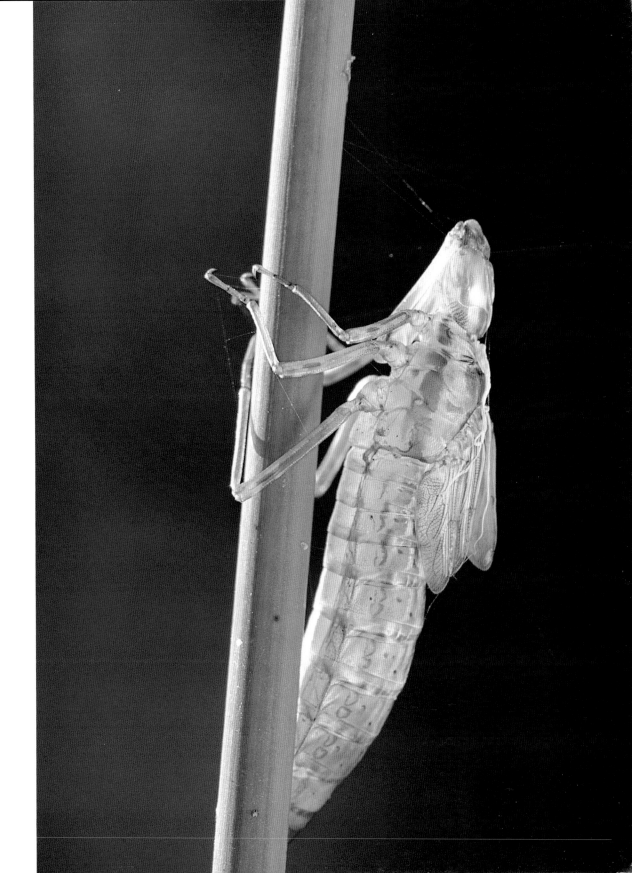

images are the products of cumulative knowledge. Left-brained, detail-oriented people have to be patient in learning to see, to develop the creative, artistic aspects of photography. Left-brained beginners often make photographs that are technically proficient but artistically dull. Right-brained, idea-oriented people must work extra hard to master the equipment. They find gorgeous compositions but can't record them well because they struggle with the technology.

Close-up photography heightens the technological challenge, because the equipment offered to us is not really designed for photographing small subjects in the field. We must innovate and work harder to translate our vision to film.

A Wilderness in a Patch of Grass

Learning to manage the art and technology is challenge enough. But then there's the knowledge that makes the crucial difference: knowl-

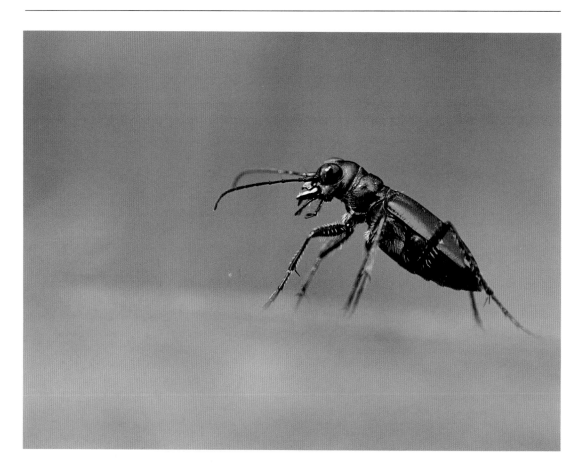

200mm macro lens with 1.4X multiplier, 50-speed film, 1/2 sec., f/11, on tripod.
(Cicindela sexguttata)
During the warm days of spring and early summer, six spot tiger beetles run down their prey on forest trails, large rocks, and old logs. Predicting this behavior allows me to be there at the right time, in good light. That's the greatest challenge of insect photography.

4

edge of your subject. What will you photograph? If you're interested in insects, which insects? Where will you find them? What do they eat? What eats them? When do they sleep, migrate, feed? How do they sound? How do they move? How do they look during each stage of their short lives?

Being the greatest artist and technician in the world won't yield great results if you haven't at least basic, at best intimate, knowledge of your subject. It is in the intimate details that otherwise good photos become great.

Insects in my backyard mark the passing seasons. Different forms come and go, some living their entire adult lives in only a day or two. Spring and the first warm days of May bring six-spotted tiger beetles, running up and down rotting logs looking for prey. They're fierce predators, the lions and tigers of the insect world. Summer means singers—grasshoppers, katydids, cicadas—dozens of insects that can be identified by song. Autumn slows things down but ushers in several butterflies that will hibernate through the winter to feed on the nectar of the first spring flowers. In winter, my property hosts as many as thirty-two insect species, including the astonishing snow scorpion fly. I watched one trekking across the drifts on a day when the windchill factor measured −20° Fahrenheit. She would live her life, mate, and lay eggs during the intense cold of that Michigan winter.

Although insects can be photographed in virtually any backyard or vacant lot, there are also some hot spots around North America that are especially good for insect photography. Places like the Florida Everglades and Santa Ana National Wildlife Refuge in Texas. Certain canyons in the Rocky Mountains yield some unique species of beetles and butterflies.

Each habitat has its own treasures. You'll find distinctly different species in hardwood forests and tropical rain forests, in savannas, woodlots, and deserts. Different inhabitants live under the soil than on its surface. One group occupies low vegetation, and another shrubs. The trees have their own tenants, and even these may vary from the lower branches to the top of a forest canopy. Knowing where to look makes all the difference in achieving the final photograph.

Where Insects Go, So Goes the Planet

The surge in nature photography is a symptom of a larger movement, a renewed concern over the diminishment of our wild places. This concern is bringing people out of buildings and back into the natural world to come face-to-face with the wild things that have been jeopardized by overuse, misuse, abuse.

We move into the world and discover again how complex our ecosystem is, how many creatures live on the same little patch of ground we've traveled all our lives. We find out how many of these neighbors we've never met before, and how many we're losing. As the world becomes uninhabitable for these residents, we discover that the balance has been lost, and the consequences for our own species are dire.

In the late 1950s, when I began my career, I was on my own. There were probably fewer than five people in the United States who were serious about nature photography. Given the vast size of the continent and the scarcity of serious photographers, we didn't as a group make much of a dent on the environment.

It's a sign of hope that more people are interested in the outdoors and in spending quality time observing the natural world. Certainly this attention has helped push laws to protect endangered species and preserve more of our few remaining wildlands. This is the good news.

But there's a dark side to all this attention. With less wild habitat and increased interest comes vastly increased pressure on the life these lands support. Certain wildlife preserves in particular have become gathering places for amateur and professional photographers. Because of this, we must assume responsibility for the mark we leave. There are now so many of us interested in photography that we must form

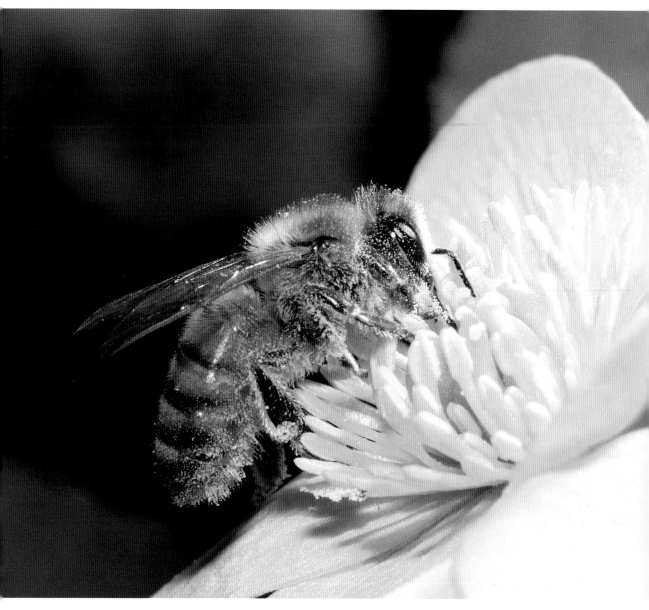

105 macro lens with 52.5mm extension tube, TTL electronic flash, camera compensation dial set at +1.0, 50-speed film, 1/250 sec., f/16, hand-held.
(Apis mellifera)
Although this marsh marigold appears a rich yellow to us, the honeybee sees quite a different flower. To the bee, the flower is bee-purple—a color unseen by humans. This happens because the flower reflects ultraviolet rays in addition to the yellow. The bee's eyes register the color as reflected by these rays. They also see guide marks leading to the flower's center. These marks do not reflect ultraviolet light. This photograph required the action-stopping ability of full electronic flash.

and agree on an ethical standard for our conduct.

There are shortcuts for insect photography that I won't teach, for instance. These involve capturing and controlling insects through the use of chemicals or refrigeration. Photographers in the past used these techniques extensively to make up for what they lacked in technology and understanding.

These techniques simply aren't necessary anymore. Given the sophistication of today's equipment, we can photograph practically any species in the field using electronic flash or natural light. Now we can record the animal going about its normal behavior. In my mind, an animal behaving naturally always results in a superior photograph. Sometimes these behaviors require a lot of creative problem solv-

ing. But for me, at least, this is one of the most exhilarating parts of photography: having to improvise, experiment, and think problems through.

How we go about photography—our attitudes as well as our actions—will determine both the quality of our own experience and the impact we have on the environment. I advocate what is called *low-impact* photography. Simply being aware of what's around you makes a big difference. Keep your eyes open, watch your step, and try to affect as little as possible.

Make your goal a fine experience rather than a fine photograph, and in the end you'll probably wind up taking better photographs. A good day in the field doesn't have to end up on film to be a good day in the field.

The Equipment

Cameras

The camera: It's a great place to begin a photographic discussion.

A couple of centuries of technological evolution have brought photographers many, many choices when shopping for this essential piece of equipment. Cameras today can do more for their owners than I ever could have dreamed when I first started taking photographs. When shopping for a camera, your range of choices may seem overwhelming, but remember that for all photographic equipment choices, you can simplify the decision by keeping your subject matter in mind. When you narrow your use to nature photography, and then further to insect photography, your equipment-buying decisions become much simpler.

Still, don't decide lightly. Buying into a camera system is a long-term proposition for most people. Once you invest in the camera system, especially in the optics belonging to that system, switching to a different format or manufacturer is expensive.

Understanding the technological choices available to you will help you choose the system that's right for you and your photographic habits.

How a Camera Works

Virtually all camera-and-lens systems use six basic components that work together with the film and photographer to make pictures. Those components are the camera body, the shutter, the viewfinder, the lens, the aperture, and the focus mechanism.

The *camera body* is light-tight and comes in many sizes, or formats. Depending on the camera type, the body may house many components. Most importantly, it houses the film plane, which holds the film in place at exactly

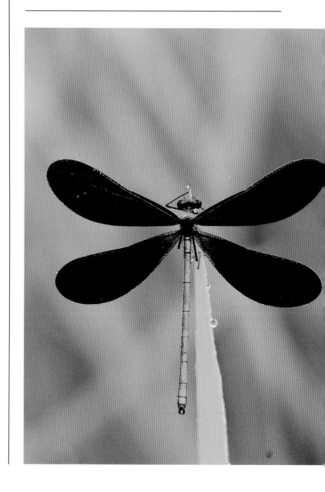

the correct distance from the lens to record an image. When we talk about camera formats, we refer to film size, or type. For instance, a 35mm camera uses roll film that is exposed in segments 35 millimeters wide.

The *shutter* mechanism is a mechanical curtain, or blade arrangement, that opens and closes to allow light (reflected from your subject) to travel through the lens and aperture to the film. The speed of the shutter's opening and closing (1/15, 1/30, 1/250, 1/500 of a second, etc.) controls the amount of time that light is allowed to expose the film.

The *viewfinder* enables the photographer to see the area of the image being photographed. Camera types are usually discussed in terms of their viewing or focusing systems. For instance, Single Lens Reflex (SLR) refers to the mirror-and-hinge system that allows the photographer to see the image right up to the moment of exposure, through the same lens used to make the picture.

The *lens*, traditionally made of glass, is the camera's eye, allowing light to carry the outside image to the film plane.

The *aperture*, or diaphragm, also works to control the amount of light that reaches the film by enlarging or reducing the opening through which light passes. The size of the aperture (f/4, f/5.6, f/11, f/22, etc.) also controls the depth of field, or how much looks sharp, in the photograph.

200mm macro lens with 1.4X multiplier, 50-speed film, 1 sec., f/11, on tripod.
(Calopteryx maculata)
Touched with morning dew, a black-winged damselfly sleeps in the grasses along a stream. These insects can be found in a range that spans much of the North American continent, flying in a butterflylike manner along streams and in forest clearings.

9

The *focus mechanism* moves the lens closer to or farther from the film or, with internal-focus lenses, moves certain lens elements back and forth to sharpen the image and to accommodate subjects at various distances.

To make a photograph, the photographer loads the proper film type, attaches the proper lens, selects the appropriate aperture size, focuses and composes the image through the viewfinder, then trips the shutter, allowing it to remain open for the correct amount of time while light carries the image through the lens and aperture to the film plane. The image is then recorded by chemical reaction on the film's light-sensitive emulsion and is ready for a processor to transform it into a permanent photographic image.

The Best Close-up Camera

Over the years photographers have made many wonderful close-up photographs with just about every format of camera in existence. Today, given all the choices, most professional and amateur insect photographers have settled on the 35mm SLR as their camera of choice. Why? Because close-up photographers need versatility. Our subjects encompass both fleas and luna moths. We may stalk butterflies for hours or make ultra-close-ups of ants or mites. Insect photographers require precise focus and compositional control.

For these reasons, we need camera bodies small and light enough to allow some grace in field stalking, yet able to hold plenty of film. We need a format that allows vast flexibility when choosing optics and film types, yet small enough that the subject does not have to be greatly enlarged to fill the frame.

Because so many photographers prefer the 35mm SLR camera, manufacturers have developed technologies for this format that make field photography vastly more productive than in years past. Most new cameras have computerized "brains" that can measure your light, set your aperture and shutter speed, do your focusing, track your subject, load and advance

your film, record the date, trip your shutter, and let you know when you're low on power.

These electronic aids make photography a much more relaxing endeavor when you want it to be, but they can't guarantee you'll get the photos you want unless you understand how they work and when it's appropriate to use them. I do not recommend investing in a camera that will not allow manual override of the electronic wizardry. We'll discuss when and when not to use these features in the chapters ahead.

Through-the-Lens (TTL) Meter

A through-the-lens (TTL) meter is what its name implies—a meter that reads light through the lens to help you determine how to set your aperture and shutter speed to deliver the best exposure for your subject. Before these sophisticated systems were developed, most photographers used hand-held meters to measure the light, but in-camera systems are light years ahead of hand-held meters for close-up work.

Center-weighted, spot, and multisegment meters are the three main types of TTL meters today. Center-weighted systems place 60 to 90 percent of the meter's concentration at the center of the image area. A spot meter narrows the sensitivity area to a few millimeters in the center of the frame to allow very selective exposure readings of a portion of your subject. Multisegment metering measures the light reflecting from several areas of the image, selecting an exposure that will reproduce the principal subject most pleasingly. This system, powered by a user-friendly on-board computer, allows photographers to balance the foreground, subject, and background and find the best exposure for the photographs they want. In many situations, multisegment metering helps even seasoned photographers manage difficult lighting situations.

Interchangeable Focusing Screens

When viewing through your camera, you see the image as it comes through the lens and

bounces from a mirror onto the focusing screen. It is then picked up by the roof prism to come through the eyepiece right side up and right way around. The screen serves as an aid to the photographer in achieving sharp focus. With current camera models, the screen installed by the manufacturer is probably the only one you'll need for close-up work, but many different focusing patterns are available. Some provide grid lines that are helpful when composing the photograph, to keep vertical lines vertical and horizontal lines horizontal. Some allow more light to pass through to your eye, which is critical when working up close in low light, as with much insect photography. If your focusing screen is more a hindrance than a help, consider a bright matte screen, the sort that is standard on autofocus cameras.

Finding the right focusing screen is a little more difficult if you're working with an older camera. The Nikon H-4 screen will work with many of the older Nikons and was one of the best screens I've ever found for this type of work. Or try ones manufactured by Bright Screen or Beattie, two companies that offer focusing screens for a wide variety of cameras.

Motor Drive

Very few cameras today come without some sort of self-contained motor drive, and this piece of equipment, I think, is essential when photographing living things. So many insect behaviors can take place during the time it takes to wind a frame of film. Motor drives advance film at speeds from 3.3 to 5.7 frames per second.

Exposure Compensation Dial

The exposure compensation dial allows you to fine-tune the exposure when your camera is in

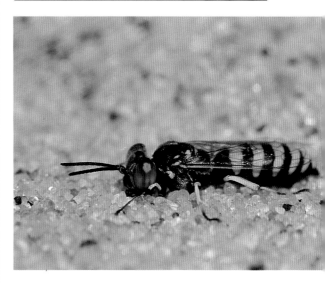

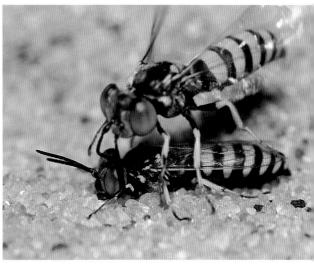

200mm macro lens with 3T close-up lens and 2X multiplier, TTL electronic flash, camera compensation dial set at + 1.0, 50-speed film, 1/250 sec., f/16, on board pod.
(Family Sphecidae)
When photographing active insects like these sphecid wasps, an ever ready camera is important. The motor drives built into the current generation of 35mm cameras provide just that. I had just made an exposure of the wasp in the first frame when the second wasp buzzed into the picture. The motor drive had done its work, and I was ready to record this behavior.

11

its automatic or programmable modes. Using this dial is the proper way to control through-the-lens flash exposures. Most cameras come equipped with this feature.

Mirror Brakes or Mirror Locks?

When you trip the camera's shutter, the mechanical movement of the lens closing to the correct aperture, the reflex mirror snapping up against the focusing screen, and the shutter bouncing open and shut can cause internal movement that shakes the camera. This can be enough to ruin all the efforts of proper focus and exposure, particularly at certain shutter speeds.

On earlier cameras, the solution was a mirror-lock device that allowed you to lock the reflex mirror out of the light path before you tripped the shutter. When you do this, however, you can no longer see through your viewfinder, which is awfully inconvenient when working on small, fast-moving subjects such as insects. Current manufacturers alleviate the problem with the use of built-in vibration-dampening systems.

Depth-of-Field Preview

For any type of photography, depth-of-field preview is a must. This feature allows you to see what is in or out of focus at the aperture you've selected. You need this feature because, in normal mode, you view your subject with the lens wide open to allow plenty of light and easy viewing. With the lens wide open, not much of your subject area will be in focus. The preview feature closes the diaphragm to the set aperture so that you can see the depth of field you'll end up with. When you close the aperture down, however, you end up with less light for viewing. Some people find the darker image frustrating, but if you allow your eye time to adjust to the reduced light, you'll come to see depth-of-field preview as an indispensable feature.

Autofocus

Autofocus isn't the answer for every photographic situation, and when photographing insects, at the current state of the technology, autofocus is more of a hindrance than a help.

One autofocus spin-off is very useful in close-up work, however. This is freeze, or trap, focus, available on some cameras or as a feature on an add-on "data back." I've had some excellent luck photographing millipedes crawling across logs in dark, rain forest–type situations where there was very little light to help me focus. I prefocused at a given point, and the camera tripped the shutter when I moved into focus on the millipede. And if you've already invested in manual-focus lenses, there's good news: Trap focus does not require autofocus lenses.

TTL Flash and Fast Flash Synchronization

Camera bodies made from the late 1980s on generally offer through-the-lens, or TTL, flash capabilities. Because mastering flash technique is so important when photographing small creatures up close, I wouldn't consider buying a camera without this capability.

And if you want to use an electronic flash in daylight to "fill in" a shadowy situation, you'll want flash synchronization at speeds up to 1/250 second to sharply record moving subjects and to prevent ghosting—the recording of a secondary overlapping image from ambient light. Most of the new cameras have flash synchronization at least this fast, but be sure to look for it on older camera systems.

New Camera or Old?

There are more features that nature photographers sometimes find helpful in the field—auto bracketing, multiple exposure programs, shutter priority features—that are useful in certain situations, but I haven't found them particularly so in my work.

If you're looking at new cameras, virtually all the 35mm SLR cameras for serious amateurs

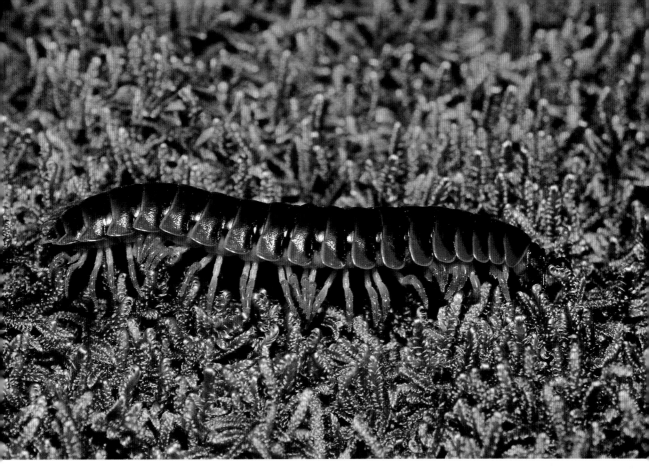

200mm macro lens with 3T close-up lens, TTL electronic flash, 50-speed film, 1/250 sec., f/16, hand-held.
(Sigmoria *sp.*)
On an overcast day in the Great Smoky Mountains, I spent several hours photographing millipedes using the freeze-focus feature on my camera. Millipedes never seem to stop, so I adjusted my lens for the proper image size, then, holding the shutter release down, moved the hand-held camera to align the film plane with the millipede. When the area within the autofocus sensors came into focus, the camera fired, and I had a sharp millipede image.

have all the features listed here. But if you're interested in buying a good used camera system, I consider the first six features must-haves: a TTL meter, interchangeable focusing screens, a motor drive, an exposure compensation dial, some kind of mirror locking or vibration-dampening system, and depth-of-field preview. The other features are awfully nice and allow you the greatest flexibility, but they're not necessary.

There are plenty of good used cameras out there that will do a great job for insect photography. I still like the Nikon F3 and the Canon T90. The first generation of the Nikon 8008 has been discontinued for a few years. These are fine cameras for close-up work.

Few older cameras have good flash capabilities. For nature photography, I would much prefer to own a new camera (even one that was not at the top of a company's line) with sophisti-

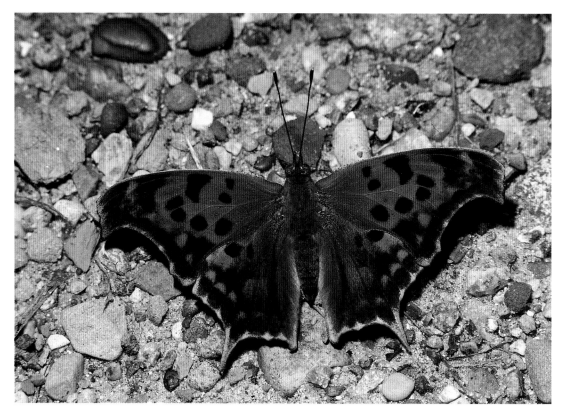

105 macro lens, TTL electronic flash, 25-speed film, 1/60 sec., f/16, hand-held.
(Polygonia interrogationis)
One hot, late August afternoon, this freshly emerged question mark butterfly showed up on a little area of damp gravel next to my house. My hand-held 105mm flash setup was ready to go, so I was able to expose a number of frames of this normally wary species.

cated flash features than an old classic without these features.

It goes without saying that when you settle on a camera, you should pore over all accompanying literature until you completely understand its capabilities. Your camera should become an extension of you, as familiar as a piano to a jazz pianist or a pen to a poet.

Lenses

Beautiful insect photographs are in part a product of luck. Finding your subjects engaged in some fascinating behavior is lucky. But luck can't help you if you're unprepared for the moment. Among both professional and amateur nature photographers, being caught with your optics down is the most common foible.

Here is a premise that applies to every piece of equipment presented in this section, but particularly to lenses: You need what you need when you need it.

I can't tell you or decide for you what you need in lenses and attachments for insect and spider photography. You need to know what kind of equipment is available and what it can do for you. I will make a few suggestions, but

your lens choices will depend on your budget and your subject matter. The optics you need are those that will give you results that will satisfy *you*.

Capabilities

No matter what your subject, your first concern when choosing a lens is your purpose. Which capabilities will you need for your subjects and style of photography? You'll need to consider focal length, shutter speed, and aperture size.

Focal Length. Focal length is measured in millimeters. The length stamped on the barrel of a lens—50mm, 105mm, 200mm—originally described the distance between the center of the lens and the film plane when the lens was focused at its farthest distance. Optics are configured many different ways now, but we still use this numbering system. The larger the number, the greater the magnification of the scene and the narrower the field of view.

When working on insect and spider photos, photographers talk in terms of magnification and working distance. When discussing magnification, close-up photographers use the term *life-size* to mean life-size as it is recorded on the film. On 35mm film, a life-size photograph is one that represents an area 1 by 1.5 inches, or the size of one frame of film. So if you placed a ladybug on a slide with a life-size image of a

200mm macro lens with 1.4X multiplier, 100-speed film, 1 sec., f/22, on tripod. (Sympetrum sp.)
I've spent many mornings in a little meadow about 5 miles from where I live. I can count on finding dragonflies there, perched where they've spent the night. I made this photograph of a red meadow dragonfly on a still, late-summer morning, using a 200mm macro lens with a 1.4X multiplier for plenty of working distance. I stopped the lens well down to gain greater depth of field.

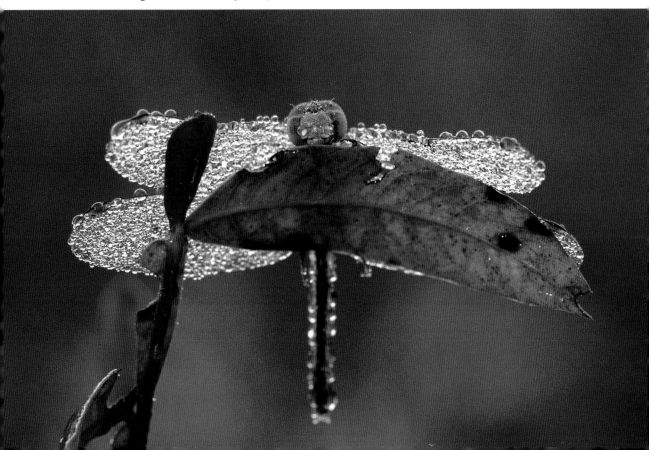

(Libellulla quadrimaculata)

If your primary lens is a short-to-long telephoto zoom, multi-element close-up lenses can offer an incredible range of magnifications. For this pair of four-spot skimmer images, I used a 75–300mm zoom plus a Nikon 6T close-up lens to cover from about 1:5 at 75mm to 1.5:1 at 300mm, without changing working distance.

ladybug, the image and the animal would be the same size.

The numbers representing magnification are given in a ratio format. Life-size is 1:1. One-half life-size is 1:2. Think of the ratios as fractions, and you'll be able to translate easily.

Because the subjects are generally very small, our goal is to magnify them sufficiently without having to get so close that we force them out of their normal behavior. Close-up photographers use a number of devices that allow their lenses to *close-focus*. Longer lenses

give you greater working distance at a given image size. I like working with lenses in the 100mm to 200mm range.

Shutter Speed. My experience tells me that insects are often inanimate objects, especially at certain times of the day. At those times I don't worry much about shutter speed. If, however, you're interested in slowing down the wingbeats of flying insects, you'll need a lot of speed. Fast shutter speeds are important in capturing sharp images of fast-moving creatures.

Subjects as small as insects require small

apertures to gain sufficient depth of field. For this reason, insects are quite often photographed using the intense light and action-stopping advantage of electronic flash.

Configurations

There are many options for getting the magnification you'll need for your close-up work. The prime lens types most commonly used in insect and spider work are adaptable short telephoto, telephoto zoom, and macro lenses.

Telephoto Lenses. If you already own a short telephoto lens, you can make good use of it for close-up photography. Lenses in the 85mm to 200mm range equipped with the proper close-up accessories will provide crisp

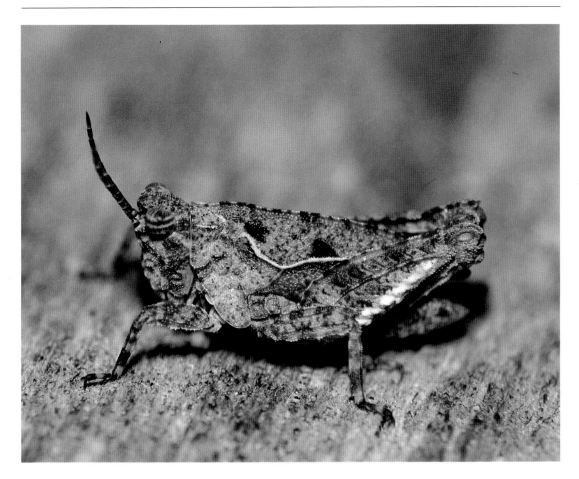

200mm macro with 3T and 4T lenses and a 1.4X multiplier, TTL electronic flash, camera compensation dial set at + 0.3, 50-speed film, 1/250 sec., f/16, on board pod.
(Family Tetrigidae)
Pygmy grasshoppers get their name honestly. This one was about 11mm long. To make this portrait, I stacked a reversed 3T on the front of a reversed 4T with an empty filter ring (spacer) in between them. This combination was on the front of my 200mm macro, with a 1.4X multiplier behind. Sharpness is great, and the working distance is about 6 inches.

images, even at greater-than-life-size magnifications. For the best quality, stick with lenses that have smaller apertures. For example, a 135mm, f/3.5 lens will give much better results for close-up work than a 135mm, f/2 lens.

Zoom Lenses. Zoom lenses in the telephoto range can be excellent close-up tools. I would pick something in the 80–200mm or 75–300mm range. My hands-down favorite close-up accessories for zooms are the multi-element close-up lenses, or *diopters*, from Nikon, Canon, and Century Optics. These help make zoom lenses very user friendly for close-up work.

Macro Lenses. Designed especially for close-up photography, these optics are my first choice for small creatures. I prefer the longer focal lengths, in the 100mm to 200mm range. With exceptional sharpness and flatness of field, these lenses focus close enough on their own to provide one-half life-size, or 1:2, magnification (see Magnification in Part III). Some have life-size capabilities without additional accessories.

The 180mm and 200mm macros feature internal focus, a feature I highly recommend. This feature is very user friendly and is silky smooth when focusing, regardless of the degree of magnification or outside temperature. I especially like my 200mm macro because it has a rotating tripod collar. When used on a tripod or flash bracket, this feature allows hassle-free rotation from vertical to horizontal formats.

Compatibility or Adaptability. If I want more magnification than my prime lens can give me, I commonly add extension tubes, multipliers, or close-up lenses—sometimes a combination of all three. At times I've ended up with four different close-focusing accessories on my 200mm macro lens. So I want that macro to work very well with add-on accessories.

Close-up Lenses

To encourage your prime lens to focus beyond its minimum focusing distance, one of the simplest solutions is to screw a close-up lens, or

diopter, to its front. Close-up lenses don't decrease the amount of light that reaches the film plane, and the optical quality of the two-element versions are very good.

Multipliers

A wonderfully flexible way of getting a larger image with a lens is using multipliers. Multipliers—also known as tele-extenders or doublers—fit between your prime lens and your camera. They do just what their name implies: They multiply the magnification power of the lens.

When multiplying lens powers, you must be careful as you head higher into the multiplication tables. You decrease sharpness and contrast as you increase the power of the multiplier. Unfortunately, using multipliers does degrade your image somewhat. The secret to working with them is starting out with a very good prime lens. A high-quality prime lens, like most macro lenses, projects more lines per millimeter than most films are capable of recording. So in this case, while you theoretically degrade the image by using a multiplier, you won't see any loss of quality on the film. Properly used, multipliers produce superb results.

Extension Tubes

I find I use extension tubes less and less for my close-up work. But they are still a good solution for adding magnification. An extension tube is a simple hollow metal spacer that fits between the lens and the camera body. Any lens combination will focus more closely with added extension. The tubes can be used alone or in combination.

"Starter Package" for Beginners

Most people who get started making nature photographs have already done some dabbling in general photography, own some equipment, and plan to build on it. But others are starting from scratch and ask me to recommend a "starter package."

Of course, my starter package would begin

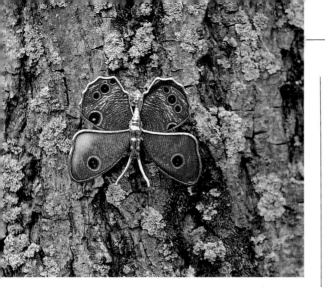

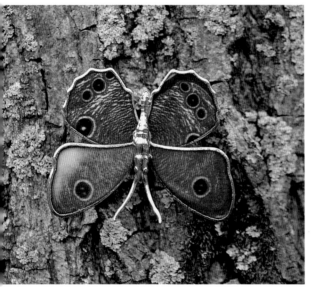

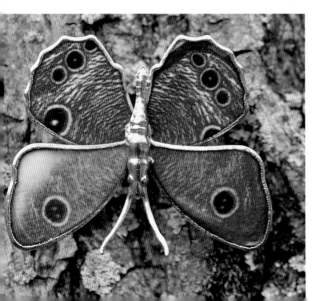

Multipliers give you added magnification without sacrificing working distance—and working distance can make all the difference when stalking butterflies. This 1¾-inch costume jewelry butterfly stayed put long enough to illustrate the effects of 1.4X and 2X multipliers when added to a 200mm macro lens, maintaining a working distance of 2½ feet.

with a 35mm SLR camera. Next, while recognizing that no one lens will do everything, I would add a 105mm or 200mm macro lens. My next purchase would be a 2X multiplier to give great flexibility in magnification. These lenses, coupled with the newer, super-sharp films, are a great combination and may be all you'll ever need.

Flash Equipment

I use flash more when photographing insects and spiders than I do for any other subjects. The ability to manipulate light, to add it in degrees from any angle, to use it to maintain small apertures for greater depth of field, are advantages simply too important for a photographer to ignore.

Yet in workshops, electronic flash has been one of the most difficult subjects for students to grasp and the one they most want to avoid. Many would rather give up a beautiful photograph than learn how it can be had with a little flash know-how. A lot of that trepidation has dissolved during the past several years with the development of through-the-lens (TTL) flash technology. We'll talk about understanding flash technology in Part III.

I recommend keeping your flash equipment simple and easy to use. I highly recommend investing in a fairly powerful TTL flash made by the same manufacturer as your camera. If you're using predominantly longer lenses, like an 80–200mm zoom or a 200mm macro, choose a larger flash (like the Nikon SB-25). If you're sticking to lenses 105mm or shorter for

19

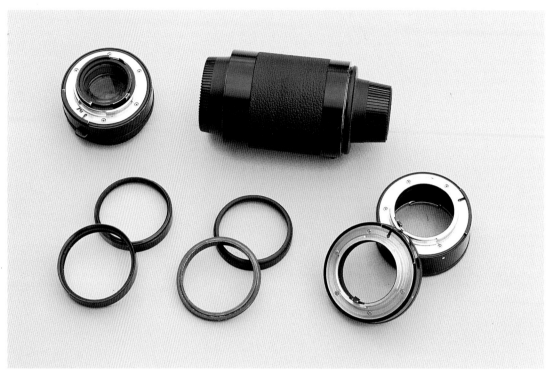

Add-on accessories—multipliers, close-up lenses, and extension tubes—alone and in combination can greatly extend the close-focus range of a good prime lens. From left to right, top to bottom, are TC-14B and TC-301 multipliers, 3T and 4T close-up lenses, a 52/52 male/male ring, an empty filter ring, and 12mm and 27.5mm extension tubes.

your close-up work, one of the smaller units on the market, like the Nikon SB-23 or the Canon 430 EZ, will work just fine for you.

TTL flashes, like TTL light meters, read the light available, and they adjust the flash exposure accordingly. They compensate for any accessories you add to your camera and any additional flash units you may attach to the system. Also look for a system that will allow you to vary the relationship between the light output of the flash and the natural light exposure. This greatly simplifies fill-flash photography.

Macro Flash Rings

Some photographers swear by macro flash ring lights. Macro ring lights consist of a bracket holding two or three tubes that can be turned on or off individually. I don't find them useful or desirable for photographing small creatures, because the flat lighting they produce doesn't give the detail, sharpness, or depth I really

(Family Muscidae)
Adding a multiplier behind a close-up setup will multiply the final magnification by the power of the multiplier without changing working distance. For the photos of a forest muscid fly, I added a 2X multiplier behind a 200mm macro with a 3T close-up lens, doubling the image size of the close-up lens setup alone. I used 50-speed film, 1 sec., f/11.

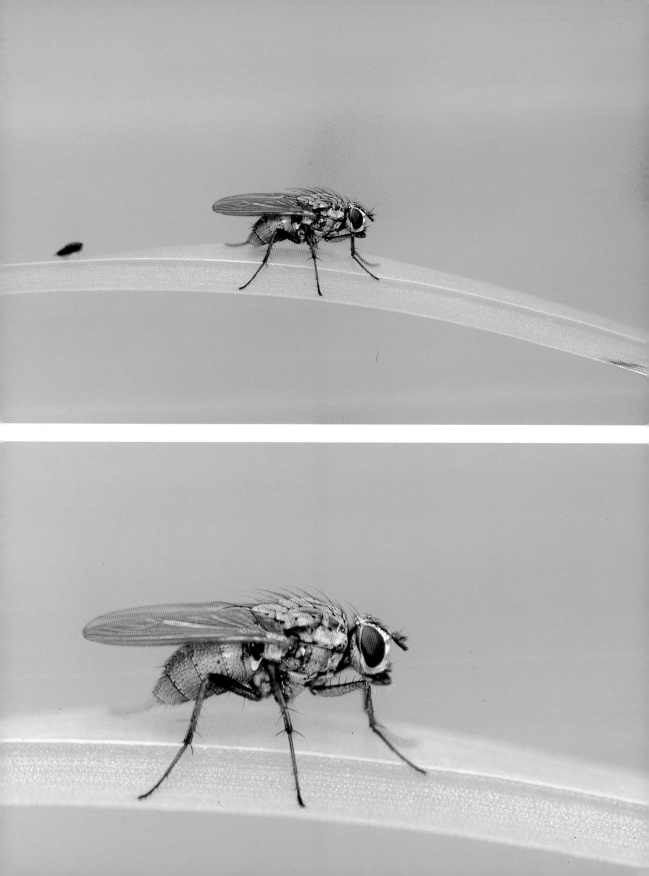

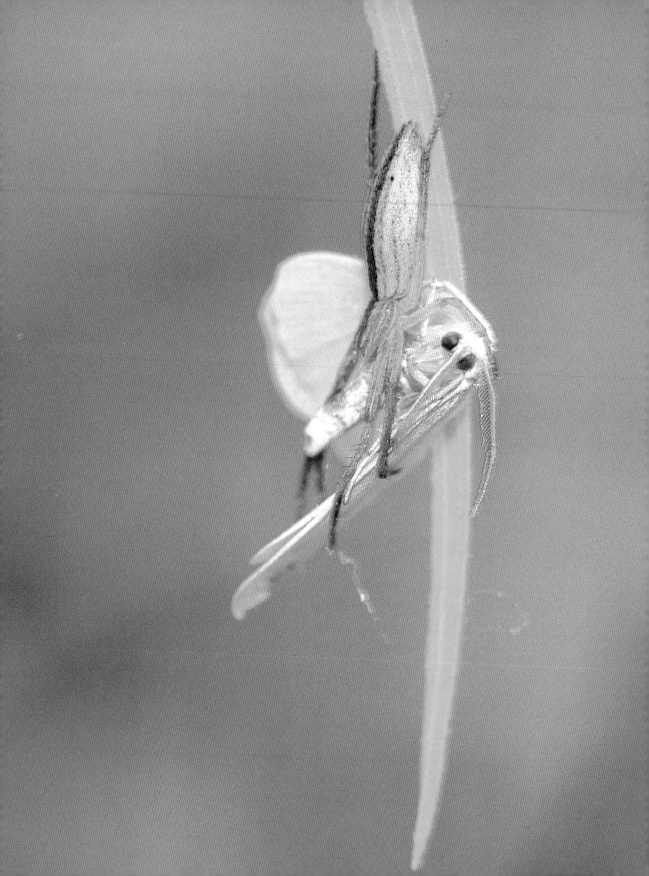

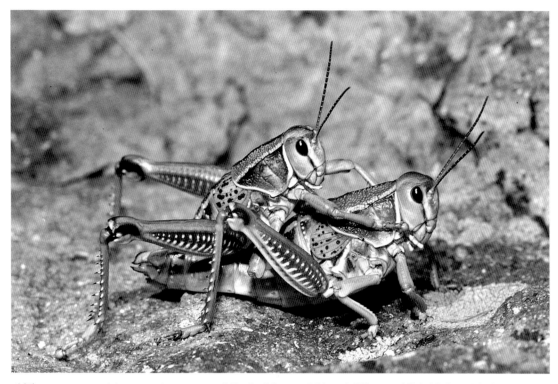

105mm macro with extension, manual flash, 25-speed film, 1/60 sec., f/11-16, hand-held.
(Brachystola magna)
Early September in Wind Cave National Park, South Dakota, is a great time for photographing pronghorns. I was ready to photograph big mammals, but the insects offered a continuous show. By a stroke of luck, I had brought along my compact 105mm flash rig. Because it was lightweight and very hand-holdable, it was the perfect setup for recording the diversity of insect species I met on the trip, including this lubber grasshopper pair in copula.

200mm macro with a 1.4X multiplier, 3T close-up lens, TTL electronic flash, flash compensation dial set at − 2.0, 50-speed film, 1 sec., f/11, on tripod.
(Pisaurina mira)
Nursery web spiders are tireless hunters, stalking their prey over the stems and leaves of plants. I first placed a 1.4X multiplier behind my 200mm macro lens, then added a 3T close-up lens to the front. Working off a tripod at a slow speed allowed the mixing of natural light and fill flash. A persistent breeze allowed only eight exposures in a half hour.

want. They're okay for the purpose they were designed for—making scientific records—but I can't recommend them for other uses.

Manual Flash

If you have an older camera system, manual flash systems are perfectly fine. They require greater understanding of flash photography, but there's no harm in greater knowledge. They also require more testing up front, but I recommend testing all equipment anyway before heading into the field. For a full discussion, see John Shaw's *Close-ups in Nature*.

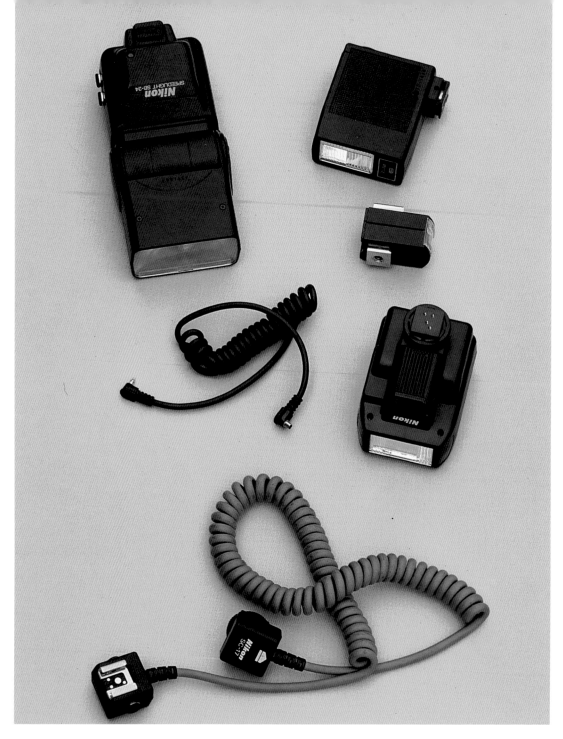

Flash equipment need not be cumbersome or complicated. I manage very well with the equipment shown here. From left to right, top to bottom: a Nikon SB-24 flash, an old Vivitar 102 manual flash and photo slave, the flash cord for my Vivitar, an SB-23 TTL flash, and an SC-17 dedicated cord for my two TTL flashes.

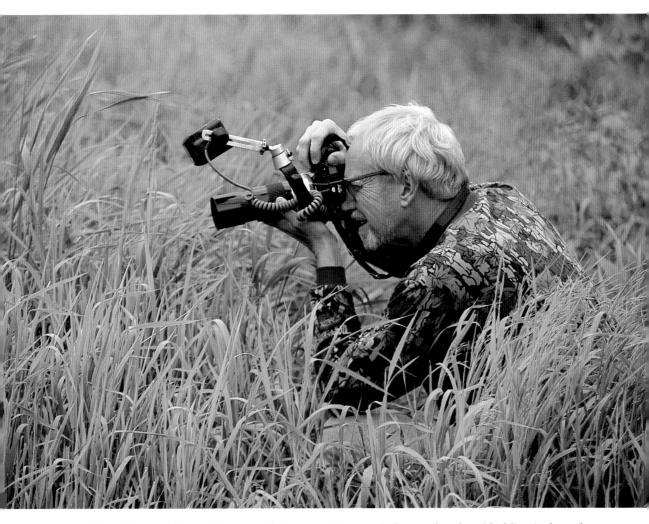

As much as I love working with support, there are times and places when hand-holding is the only way to get a picture. I brace the camera as best I can, positioning my body to minimize movement. Besides, it's sometimes just plain fun to walk around with a hand-held setup, unfettered by a tripod.

Flash Brackets

When photographing small creatures, you'll want to move any flash unit off your camera's hot-shoe to get a better, more natural angle for the light. For this you'll want a dedicated flash cord. Always use flash cords that are made by your camera's manufacturer, or you run the risk of locking up or ruining your equipment.

And then, depending on your taste and habits, you'll want some sort of mounting bracket for your flash.

If you're photographing hand-held or on a tripod, especially with the longer lenses, 105mm or longer, you're going to want some way of holding and repositioning your flash while operating the camera with both hands.

25

There are some great flash brackets on the market. I use one offered by Kirk Enterprises (see Resources). My bracket is heavy enough to support everything, it's adjustable, and it allows me to make vertical and horizontal photos easily. Be careful when investing in flash brackets. Most on the market today were designed to be used with small manual flashes and aren't heavy enough to handle the new, beefier super-flashes.

The unit I use is made for a 200mm macro lens. Mike Kirk and I worked out the design specifically for this sort of photography. It mounts on an Arca quick-release plate, so the whole setup can slide back and forth in the quick release, which is great for the fine-tuning you need when composing photographs of small areas.

More than One Flash

I have tried over the years to use two flashes on a bracket. Once in a while I ended up with better light than with a single flash, but when working in small spaces, double shadows are common. This can be overcome by making sure one light is considerably weaker than the other. I've abandoned the idea of using two lights, because I don't find the outcome has a natural quality, and the setup is just too bulky and unfriendly for graceful fieldwork.

Support

Hanging flies are fascinating creatures. They hang out in deciduous forests, swaying with the breeze but otherwise remaining still until smaller insects fly by. They use their hind legs to grab dinner out of the air. To photograph this creature, you need to place yourself in the perpetual twilight under a forest canopy. In this low light, if you use total flash on a subject that hangs in midair, the background will look black. You'll want as much natural light as you can get, with some fill flash to highlight your subject. A long natural-light exposure means you'll need good support to keep the camera

rock steady, or you'll end up with a fuzzy hanging fly.

Generally speaking, the more mass or weight supporting your equipment, the crisper your pictures will be. Of course, the more mass you have to carry, the slower you'll move in the field. Let's explore the options.

Hand-holding

My hand-holding technique is to try to turn my body into a tripod. I first try leaning on any stable source in the immediate area—a tree, a rotting stump, something. If there just isn't a stable item around, I get down on both knees, brace my elbows on my knees, and keep my upper arms tucked tightly against my torso to make myself as stable as possible. If I must stand, I lean into the composition, tripping the shutter just as the subject comes into focus.

In situations where hand-holding is essential, electronic flash will allow shutter speeds that eliminate any blur resulting from your movement. But even with electronic flash, the beast you're fighting when working up close is keeping sharp focus. Especially when working at high magnifications, it's easy to move your equipment out of focus simply by taking a deep breath.

Walking-Stick Support

One step up from hand-holding is using a walking stick. The one I like to carry into the field is just an aluminum tube wrapped with duct tape

200mm macro lens with 3T close-up lens, TTL electronic flash, camera compensation dial set at + 0.7, 50-speed film, 1/250 sec., f/16, hand-held.
(Poanes viator)
In the sedgy clearings of wet woods, where the broad-winged skipper flies, it's hard to maneuver a tripod. In this situation, my 200mm macro with close-up lens gives me a good working distance and is very hand-holdable.

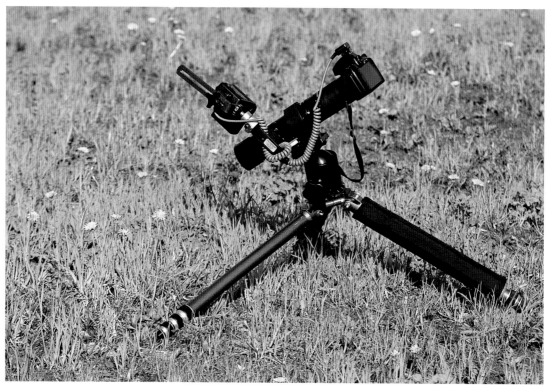

If I can use a tripod for very small subjects, I do. I like to think of myself as steady, but I'm no tripod. The tripod allows a much higher percentage of good compositions, more pictures in sharp focus, and a more precisely controlled depth of field.

so it's warmer to the touch and won't scratch my equipment. I don't fasten the camera to the rod in any way but simply brace it on the ground and wrap my left thumb around it at any height, then catch the front of my lens with the fingers of my left hand. If my subject changes position, I can easily move up and down the pole, and tilt left or right, forward or backward.

The walking-stick pole is not the most stable solution, but it's a very workable one, especially when I'm in wet places where it's difficult to set up a tripod.

Tripods

The most versatile field support for photography is a good, sturdy tripod, a tripod with mass. I looked long and hard for a tripod that is small enough to carry around, yet heavy enough to support my equipment. A good tripod is so important to me in the field that I usually choose to leave extra lenses or camera bodies at home, trading in some optical versatility in favor of support, because the tripod is critical for sharpness.

My tripod's legs extend enough to raise my camera to my standing eye level without any center-post extension. On any tripod, center-post extension will exaggerate the wobbles you're trying to avoid. My tripod legs also spread far enough to bring my view very close to the ground. For most of my insect work, I currently use a modified Gitzo 326, which has no center post.

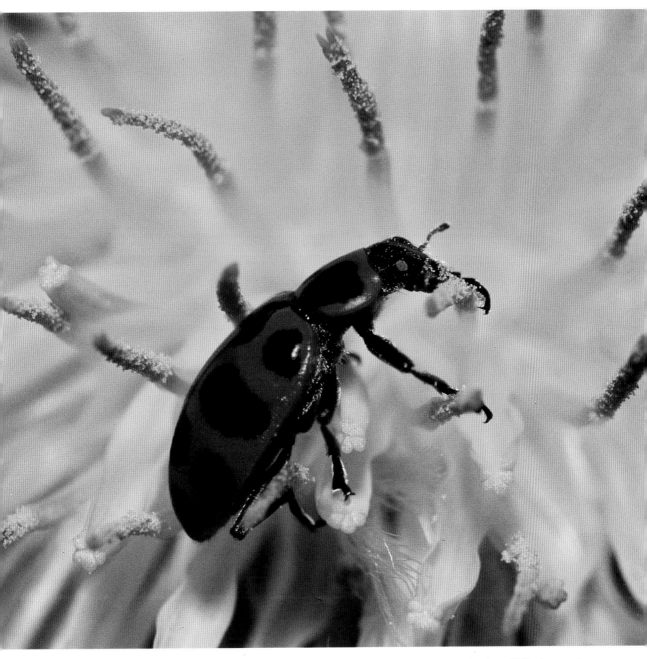

200mm macro lens with 3T close-up lens, PK-13 extension tube, and 2X multiplier, TTL electronic flash, camera compensation dial at + 1.0, 50-speed film, 1/250 sec., f/22, on tripod.
(Ceratomegilla maculata)
I postpone my first spring mowing until the spotted lady beetles have left the dandelion blossoms on my front lawn. For these magnifications—about 2:1—a tripod really helps.

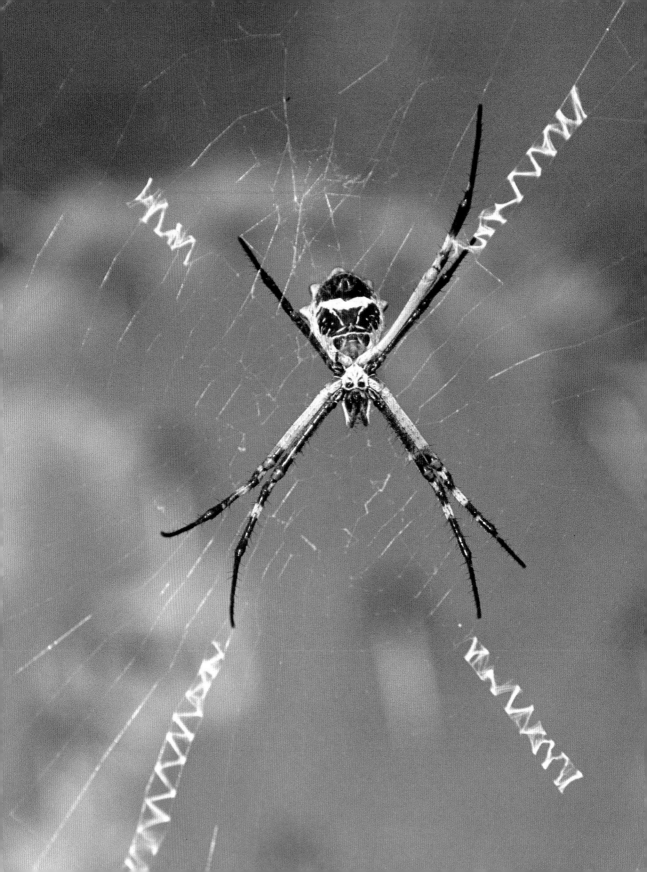

Carrying gear in the field usually means balancing your tripod on one shoulder and hanging a camera bag from the other. If your tripod is as sturdy as I'm suggesting here, and you have a ball-head, camera, and lens mounted to it, your shoulder will be bearing a significant weight. You'll find padding your tripod legs a big help. Padding also protects expensive equipment if you forget to tighten down your tripod head, and your camera and lens come crashing into the leg.

There are some handsome leg-padding accessories available on the market. Tri-pads, for instance, are made of rip-stop nylon and padding. They go on easily, attaching with Velcro, and can be removed easily for cleaning. Before such specialty items came to light, we old-timers used plain old foam pipe insulation. It goes on tight, works very well, and is inexpensive, if not very pretty.

Ground Support

A lot of insects and spiders live close to the ground, so a low-angle support that is maneuverable and environmentally friendly is a very handy accessory. I've made a 10-inch circular "board-pod" out of a piece of plywood. I simply bolted my large ball-head to it to create a very maneuverable support for crawling around on the ground. It doesn't bore holes into anybody's burrows, but just sits on top of the ground,

200mm macro with a 1.4X multiplier, 100-speed film, 1/8 sec., f/11–16, on tripod.
(Argiope argentata)
A sturdy tripod was an absolute must for this photo. This lovely silver argiope had spun its web in an enormous prickly pear cactus growing in the Laguna Atascosa National Wildlife Refuge in southeast Texas. To stay out of the cactus spines, I needed working distance. I managed that with this lens combination but needed a slow shutter speed. The tripod allowed 1/8 of a second.

offering great stability and a lower point of view than any tripod I've found. A terrific unit like this one is now available through Kirk Enterprises (see Resources).

Beanbags are another favorite support used by many photographers. A beanbag can hold your camera in place on the ground or on a rock or stump, protecting your equipment from scratches.

Tripod Heads

Something that is just as important as owning a good tripod is owning a good tripod head. A tripod head is essentially a mechanical joint that you can place between the camera and support, allowing you to tilt and turn your camera and lens.

The most popular tripod heads come in two configurations: pan-tilt heads and ball-socket heads. Pan-tilt heads offer great precision through individually adjustable controls that govern movement along three axes. These heads let you fine-tune and lock down each adjustment, which comes in handy when you have lots of time to set up and compose a photograph. But for insect photography, where a speedy response is often critical, these heads are not my first choice.

I'd sooner choose a heavy ball-socket head. The original model of these is the classic Arca Swiss Mono-ball. Today there are many Mono-ball clones on the market, in various sizes and configurations.

The classic model comprises a large Teflon ball and a very rugged frame. Because of its mass, it will support virtually any lens. The ball-and-socket construction allows you to freely maneuver your camera and lens, then lock it into place.

Look for a head that offers a separate, smooth pan control, so that you can follow the action of walking or flying creatures without unlocking the main controls. Look also for comfortably located locking levers and knobs—ones you can adjust without taking your eye from the viewfinder.

31

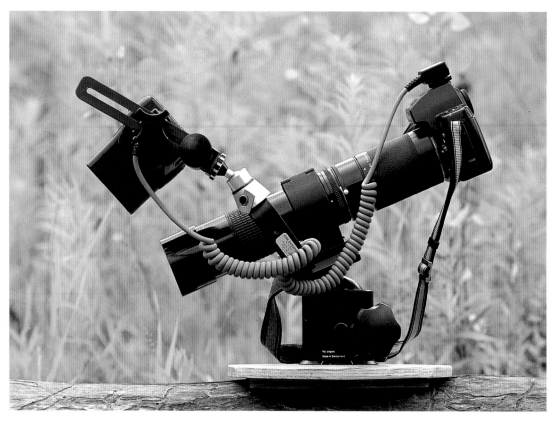

For low work, lower than I can go with my tripod, my homemade board pod takes me as far down as possible without sacrificing the flexibility I get with my tripod head and brackets.

Focusing Rails

A focusing rail is simply a geared device that allows you to move your camera and lens forward and back for fine focusing. These are essential if you're using shorter focal-length lenses without internal focus for close-up work. They're a necessity with a 50mm macro lens, not quite as important with a 100mm lens, and not really necessary with a 200mm internal-focus lens.

Quick-release Plates

When you suddenly need a different lens, or another camera system altogether, you'll bless the soul who invented quick-release systems.

My favorite quick-release is a heavy Arca-style one. The Arca system's dovetailed plates slide back and forth, often eliminating the need for an extra focusing rail.

My second favorite quick-release system is the Bogen hexagonal-plate system. The Bogen system is very sturdy, but it is fixed within the mount, so it is not quite as responsive as the Arca design.

Film

Choosing what film you'll put into your camera can be much more mystifying than choosing the camera itself. At the rate new films and updated emulsions enter the market, even pro-

200 macro lens with a 1.4X multiplier, 100-speed film, 1/2 sec., f/11, on tripod.
(Hamadryas feronia)
In the soft light of a Rio Grande thorn forest in south Texas, a white-skirted calico butterfly's protective coloration enables it to blend with its resting place. The use of 100-speed film allowed a reasonable exposure in the dim lighting.

33

fessional photographers, whose film loyalties run deep and strong, find themselves confused.

Confusion is built into the system. Film companies work at a sort of alchemy, melding aesthetic concerns with emerging technology in their search for the perfect emulsions—those that will consistently deliver the "ideal" image. Unfortunately, the technologies are not consistent, and no one agrees what makes an image ideal. Fortunately, our subject narrows the field of possibilities. For photographing tiny creatures in great detail, often with the help of electronic flash, the field of suitable films is narrow enough that making choices is much more interesting than exhausting.

The best insect and spider photographs would be made with an emulsion that delivers razor-sharp images at fairly high speeds. This film would display all the fine detail, color, and contrast of the most resplendent butterflies, and all the rich and subtle distinctions of tone and color of an iridescent dragonfly.

Color Negative, E-6, K-14?

Professional and amateur nature photographers tend to use transparency films. If you are a print film fan, there are marvelous emulsions available and being developed in the 25 to 400 ISO range that will be right for your close-up work. Talk with your film representative to find out which print films would be right for you.

When we talk transparency film, we're really talking about two types: coupler-in-emulsion, or substantive, films, also known as E-6 films; and coupler-in-developer, or nonsubstantive, films, the K-14 films.

With the coupler-in-emulsion, E-6 films, color coupler molecules embedded in the emulsion form dyes that create color in the transparency. These films are the Ektachromes, Fujichromes, Agfachromes, and Scotch Color Slide films. For coupler-in-developer films, the color is produced during the K-14 developing process. These are Kodak's Kodachromes.

At this writing it's impossible to point to any one film that is the hands-down best for close-up photography. I know that I want sharpness, color that I like, and as much speed as I can get without losing detail or color. So let's consider these requirements.

Sharpness and Speed

Sharpness and speed have historically been rivals where film choice is concerned. In general, the faster the film, the more grainy the image. With close-up work, slow, sharp films give very little flexibility in shutter speed and depth of field (another good argument for mastering flash photography).

Film speed is expressed by an ISO (International Standards Organization) number. (We old-timers remember these as ASA numbers, but ISO is today the measurement organization recognized by film manufacturers around the world.) ISO numbers describe the film's sensitivity to light. The lower the number, the "slower" the film. Slow films, those of ISO 25 to 64, require greater exposure to light.

The fast slide films, with ISOs of 400 or more, require less light, but fine markings and luminous colors get lost in their grain. (Color negative films tend to give better results than slide films in faster emulsions.)

My tastes run to slow-to-medium-speed slide films. I have found speeds of 50 to 100 to be very workable for most situations, and the ever-improving sharpness of films in the 100-speed selection is astonishing.

Color

Studying color qualities of films can be both fascinating and frustrating, but it's important to understand what sort of color performance you can expect from various films. People believe they want films that yield "true color." But Isaac Newton taught us that there is really no such thing as true color. Color is an experience of waves of light and exists only in the mind of the beholder. Remembered color is nearly always more vivid than experienced color. We remember hues as more saturated, dark colors as darker, light colors as lighter.

Film color needs to satisfy our memories' perceptions. Some films give very vivid, saturated colors. Others are more muted. Many have a cast, or bias, toward one color or another. Some are more magenta, some warmer yellow, others cool, or blue. What it comes down to is taste; the only way to know your preferences is to test the films.

A Film to Suit Your Habits

While you're keeping thoughts of speed, sharpness, and color preference in mind, don't forget to consider your photographic style. You'll want to use films that are readily available. Remember, too, that a film's age affects image quality. By opting for *professional films*, you can guard against using film that is either too young or too old.

Most film types offer a choice between amateur and professional emulsions. Professional films are usually the same emulsions as the amateurs but are aged in batches by their manufacturers, who match them to rigid speed and color specifications. These batches of film are monitored for professionals who demand consistent image quality.

Stay Tuned

I like the idea of standardizing on one or two films, to keep life from being more confusing that it needs to be. But if you take this advice, do keep your ear to the ground. There are plenty of photography periodicals on the market that render sound professional opinions on the performance of new and updated emulsions (see Resources).

Currently, I'm using Fuji's Velvia 50 for my insect and spider photographs. But the science of film manufacturing is changing faster now than ever before. I am almost positive that the film I'm using today won't be the film I'll be using two years from now. Remaining open to changes will allow increasingly more creative approaches to your subject matter. And when the alchemists of the film industry have arrived at the perfect emulsion, you'll be ready.

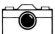

A Larry West Portfolio

It's a classic scene, the hunter wearing down the prey. Dinner is imminent for one, death for the other. This drama plays itself out a thousand times a day, all around us. But how often do we see it?

On a warm, late June day, West brought a friend and his sixteen-year-old son to this sand-blow in northern Michigan to photograph tiger beetles. The two men had prepared the boy for disappointment—tiger beetles like this one, the beautiful tiger beetle, or *Cicindela formosa,* are very hard to photograph. Get within 10 feet of one and it will typically fly 20 to 30 feet away,

Beautiful Tiger Beetle and Tent Caterpillar (Cicindela formosa *and* Malacosma americanum) *105mm lens, plus extension, electronic flash with camera compensation dial at + 1.0, 25-speed film, 1/250 sec., f/16, hand-held.*

leaving you to begin your stalk all over again.

To make a decent photograph of such a subject, you must kneel, then stretch flat out on the sand, 10 to 20 inches from the beetle, moving very slowly and being careful to protect your equipment from blowing sand.

This tent caterpillar, ill advisedly, had left the safety of its communal web, crossing the open sand in the daytime. Both insects were terribly intent on one another, so West had time to bring his friends around to see, assemble his equipment, and expose an entire roll of film before the beetle completed its task. Tiger beetles obtain all their food through predation, making them the insect equivalent of lions and tigers.

The young photographer wasn't at all frustrated by tiger beetles that day and has since become an agile and accomplished tiger beetle photographer.

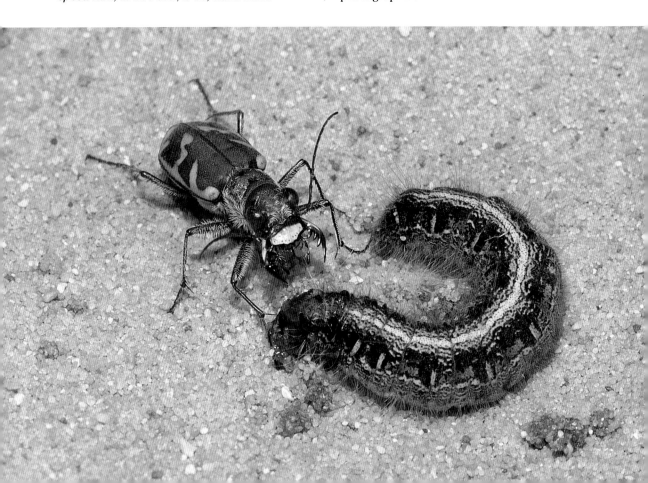

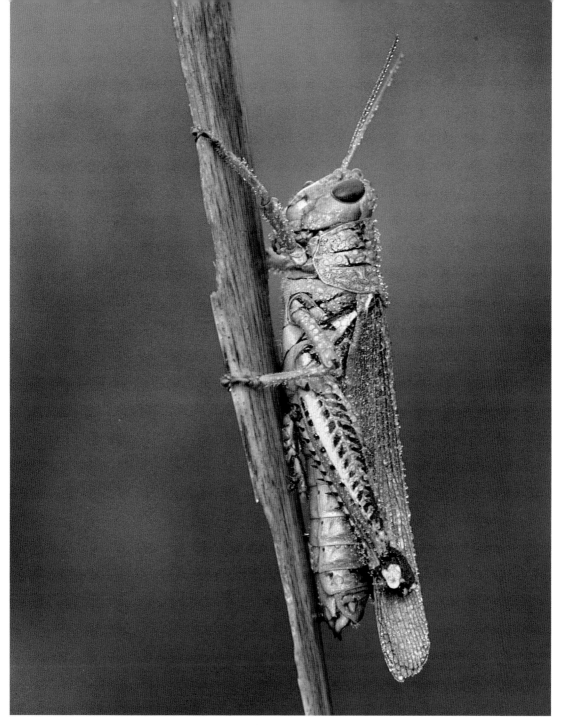

Differential Grasshopper (Melanoplus differen-
tialis)
*200mm macro lens with TC-14B multiplier, 100-
speed film, 1/4 sec., f/11, on tripod.*

Some days there seems to be nothing to photograph. Or the photographs just don't come easily. Or the equipment isn't right. Or you run out of film. Then there are other days when the light is magic and the subjects are just waiting for you.

This was one of those magic days. A late September Michigan morning. Autumn palpably in the air. Early. West was out walking, without his equipment, just an exploratory jaunt to see what he could see. The soft pastel colors, the softness and evenness of illumination in the early morning light—it occurred to West that this was his favorite kind of light, that it was a windless, beautiful morning. Then he crossed a little marsh and found the grasshopper (page 39), waiting on this cattail where it had spent the night.

He went home for his equipment.

When he returned, the insect was still there, a large, beautiful subject, easy to photograph using natural light.

American Copper (Lycaena phlaeas)
200mm macro lens with TC 14B multiplier, 100-speed film, 1/4 sec., f/11, on tripod.

West is a morning person. He gets out early when the world is fresh. Hundreds of mornings, thousands of mornings afield, West has worked to photograph dew-jeweled insects and single dew drops. For years he quit just a bit too early. If you wait for the dew to dry, you get to see "The Awakening"—the hour when all manner of winged creatures have dried and warmed and begin to take flight. Just minutes before he photographed this American copper, the butterfly slept, unnoticed by West, with its wings folded. As it warmed and dried, it unfolded its wings, along with dozens of its kin, and West began photographing in earnest.

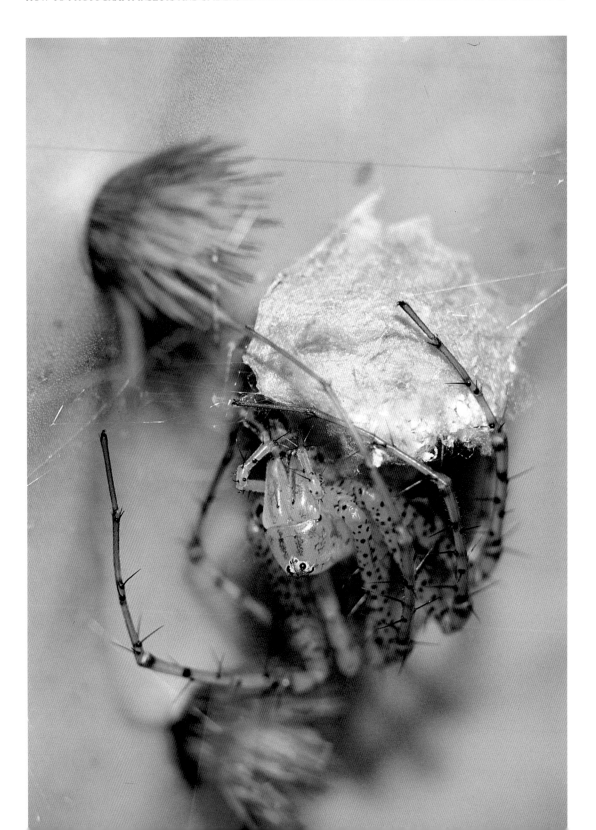

Green Lynx Spider with Egg Sac (Peucetia viridans)
200mm macro lens with TC 14B multiplier, electronic flash with no compensation, 50-speed film, 1/250 sec., f/11, on tripod.

The hazards of nature photography usually have little to do with the subjects themselves but with the sometimes inhospitable habitat in which they live.

West photographed this green lynx spider near McAllen, Texas. Green lynx spiders are large hunters related to crab and wolf spiders. The females use webbing to make a protective cover for their egg sacs, then typically rest atop the nest. This spider chose an enormous prickly pear cactus on which to build her nest, which made a photographic approach rather difficult.

West was in the field with several friends who had traveled to west Texas together on a photographic tour of Santa Ana National Wildlife Refuge and other nearby refuges. It was November, when many of the large spiders were intent on guarding their egg cases, making them easy to photograph. Though he used electronic flash to make the photo, West mounted his equipment on a tripod to be sure the composition remained well framed. Well-intentioned but sloppy compositions are one of the difficulties of hand-held photography.

The danger lay between the cactus and the bent-over posture the photographers were forced to assume. Those engrossed enough to lose track of their surroundings were rudely awakened.

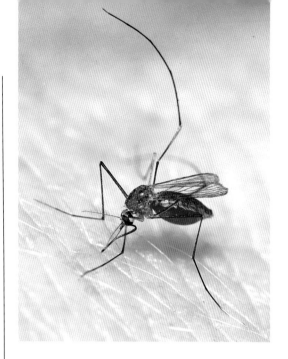

Mosquito Biting (Wyeomyia sp.)
200mm f/4 lens with 105mm short mount used as a close-up lens, 25-speed film, 1/250 sec., f/32, on tripod.

There are a few ways of distinguishing the professional nature photographer from the hobbyist. Professionals seem to make that extra sacrifice in their quest for interesting photos.

West produced this biting mosquito portrait on Snakebite Trail in Florida's Everglades National Park. West, who is rarely bothered by mosquitoes and doesn't mind much when they do bite, was walking along the trail when he noticed the unusual way these mosquitoes held their legs while biting him. Knowing he had a species here he hadn't seen before, he decided to let them bite—a good way to get them to hold still.

Trying to get a mosquito to bite on a portion of your body where it's easily photographed is another problem. It requires some fairly strange maneuvering, with equipment at the ready. As West worked on this photo, he chuckled to himself over what other people on the trail must be thinking of the white-haired man trying to lure mosquitoes to his hand.

Back bent over flower and spider, having maneuvered the tripod for what seemed like the millionth time, West finally found just the angle he needed to place spider and flower in a beautiful composition. West rarely loses patience, hardly ever gives up. This is not a pursuit for the "type A" personality, this close-up photography.

It takes a little knowing to realize when an unusual photograph presents itself. This white crab spider, commonly called a goldenrod spider, is a variety you'd typically find waiting for prey on white or yellow flowers. The creature can camouflage itself on flowers of these shades by turning yellow or white as needed to blend. Unlike spiders that catch their prey by using a web or running it down, crab spiders simply wait for something delicious to come by. The last place you'd expect to find this spider is on an extravagantly fuchsia-colored showy lady's slipper.

Showy lady's slipper blooms in northern Michigan toward the end of June. Every year West makes a pilgrimage to photograph the flower. This day, the crab spider sat stunningly out of place on the bulbous lip of this blossom.

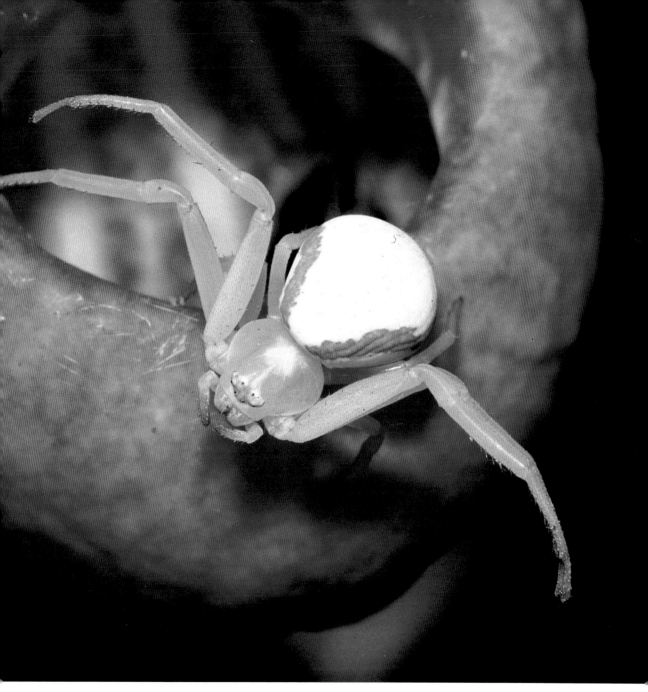

Crab Spider on Showy Lady's Slipper (Misumena vatia)
105mm macro lens with added extension, electronic flash with camera compensation dial set at + 0.7, 50-speed film, 1/250 sec., f/16, on tripod.

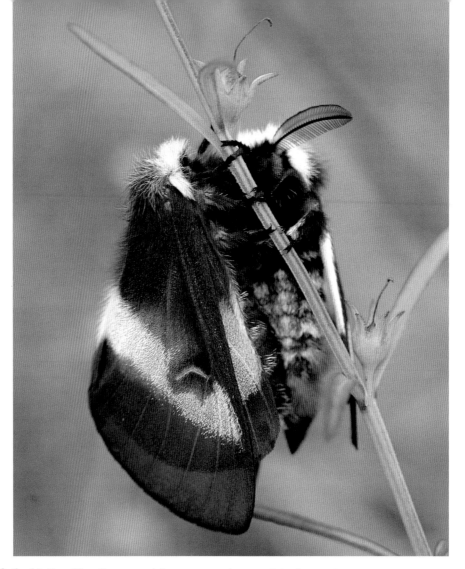

Buck Moths Mating (Hemileuca maia)
200mm macro lens with TC 14B multiplier, electronic flash with flash compensation dial set at −2.0, 50-speed film, 1/8 sec., f/11, on tripod.

West has never underestimated the power of the seasons to change the nature of a place. He has taken hundreds of students to this pond during his workshops in May, June, July, August, and October. But he'd never seen the pond in September until this day. On the way home from places farther north, he stopped and found that the land around the pond had been transformed into a buck moth free-for-all.

Buck moths are large, day-flying moths that fly in early autumn. The larvae feed on willows, which grow profusely around this pond. Thousands of buck moths were on the wing, flying about in the frenzy of their short adult lives. Knowing he had a better chance of approaching individuals involved in mating, West photographed these two quite distracted moths.

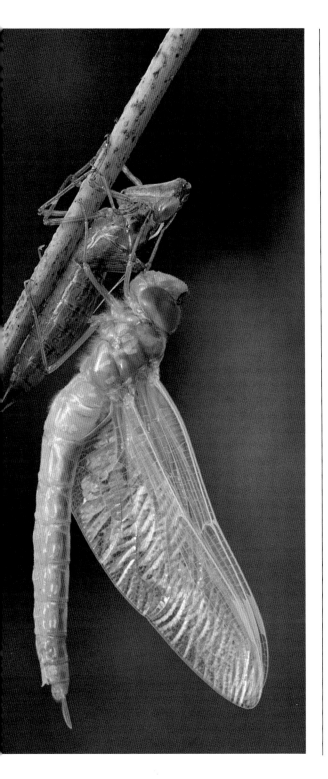

Green Darner Emerging from Nymphal Skin
(Anax junius)
200mm macro lens with TC 14B multiplier, 100-speed film, 1 sec., f/11, on tripod.

On the same spot at the same pond that yielded the buck moth photograph, a month and a half earlier, West made this photograph of a newly unfolded green darner.

Like butterflies and moths, dragonflies go through a complete metamorphosis, changing form and lifestyle as they grow. Dragonflies start life as naiads, aquatic larvae that capture insects, tadpoles, and small fish. When fully grown, naiads crawl out of the water, then split their skin along the midline of the thorax, to emerge as adults.

Once out of its naiadal skin, an adult's wings pump up over a period of an hour or two. This little pond is West's favorite for scouting out emerging dragonflies. The edge is shallow enough to wade in hip boots or waders. On good mornings in August, West has counted a hundred specimens around the edge of the pond, hanging on cattails and reeds. Most of the adults emerge during the night, when they're less vulnerable to bird attack. But there are always a few hanging on the edges of the pond in the morning.

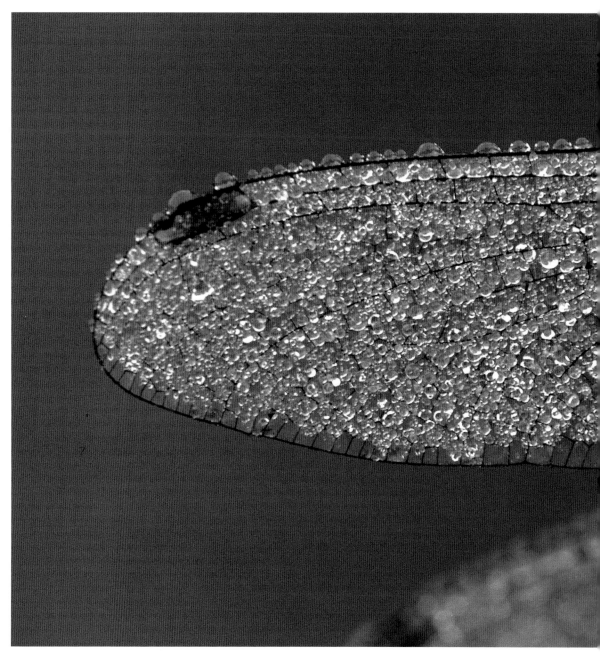

Dragonfly Wingtip (Sympetrum *sp.*)
200mm macro lens with 4T close-up lens and
TC 14B multiplier, 100-speed film, 1 sec., f/16,
on tripod.

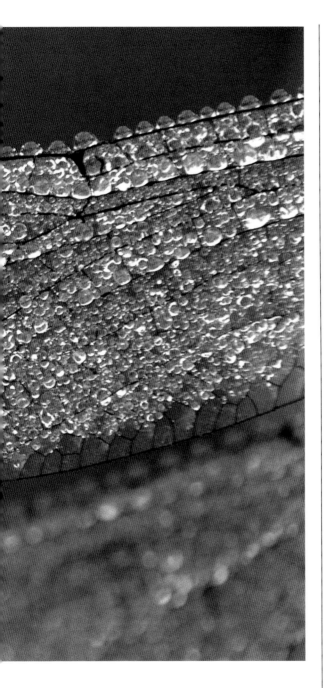

West is as much an artist as a technician. He stops now and then to study the elemental nature of his subject. This dewy dragonfly wing offers meditations on balance, line, color, and mass. It's a study of black and white, of positive and negative space. It raises questions about the physical properties of flight, about the balance of delicacy and strength in machines and creatures built for speed and agility. And in the end, it's simply a dewy dragonfly wing.

Insects become naturally chilled during cool nights. In the morning, they're immobile until they're warmed by the sun. Then they're able to shake off the dew and go about their lives. On a windless morning, West takes his time, playing with light and composition.

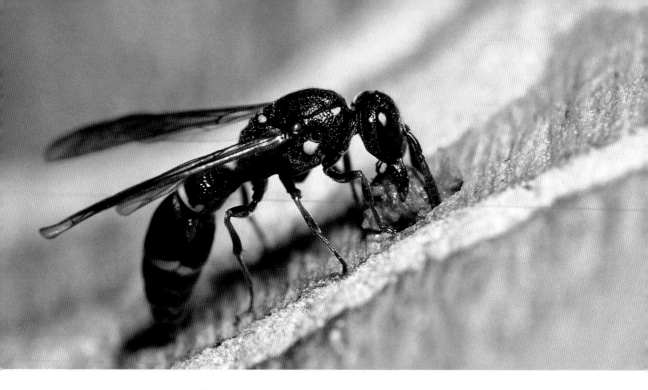

Solitary Vespid Wasp with Mudball (Family Vespidae*)*
200mm macro lens with 4T close-up and PK-13 extension tube, electronic flash with camera compensation set at + 0.3, 50-speed film, 1/250 sec., f/22, hand-held.

West's 28-acre backyard in south-central Michigan could quite easily be the most photographed property in the state. He has never exhausted his land's offering of photographic subjects and has never tired of the marvelous engineering for survival demonstrated again and again by the species who share this spot.

A fallen log stripped of bark, a two-minute walk from West's back door, is a sort of cosmos in itself. He's spent many, many happy hours with his nose to that log, watching and photographing. Many species of insects and spiders live in crevices and cavities on the log or hunt over its open surface. On this particular day, West discovered this solitary vespid female rehabilitating an old beetle burrow to make her nest.

When we think of vespid wasps, we usually think of communal species, like yellow jackets or bald-faced hornets, which work together to build communal paper nests. But there are many vespid species that work alone, constructing clay pots or mud-lined tunnels for their larvae.

Once this wasp has cleaned out the beetle burrow, she will build her mud chambers in the cavity. Each chamber will contain one egg. For the larva's provisions, she will fill the cell with caterpillars. Then she will seal the chamber with a mud pellet and begin to build another.

Making this photograph required careful camera positioning. The position was too awkward for any kind of tripod or support, so West hand-held the camera, using a small electronic flash to ensure sharpness.

Scarlet and Green Leafhopper (Graphocephala coccinea)
200mm macro lens with 4T close-up lens, TC 14B multiplier, 50-speed film, 1/2 sec., f/11, on tripod.

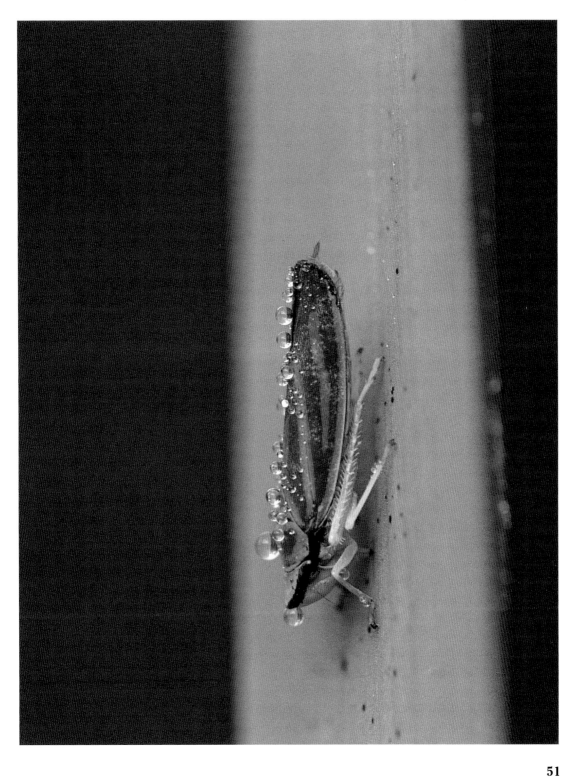

West found this leafhopper (page 51) on one of his morning quests. He was intent on photographing single drops of dew, so he had his camera and tripod along. The Day-Glo colors of this 3/8-inch insect caught his eye. After working his equipment in close to the cattail blade the leafhopper was resting on, West spent the next hour with his eye glued to the viewfinder, watching for lulls in the breeze.

These leafhoppers feed on plant juices. Adults spend the winter in leaf litter on the ground, emerging in early spring to thrust their eggs into the soft tissues of host plants.

Common Sulphur (Colias philodice)
200mm macro lens with TC 14B multiplier, electronic flash with flash compensation dial set at − 2.0, 50-speed film, 1/2 sec., f/16, on tripod.

Butterflies and moths captivate people. They present a special, lovely challenge for insect watchers in the way that wood warblers captivate birders in the spring. They unfold in astonishing colors, shapes, and sizes, in limited editions at specific times of the year. All by themselves, butterflies make for a fascinating hobby.

Patience, the willingness to wait, to fail, to begin again, to try one more time—these are the qualities that have helped West succeed as a nature photographer. He found this butterfly late one evening after it had settled down for the night. It was a lovely specimen, in a terrific setting, yielding clean compositions. Everything worked except the light. It was okay, but it wasn't beautiful.

West made a few frames but figured the sulphur had bunked in for the evening and would be there if he returned in the morning. It was good figuring. The subject was there, and it was a lovely, still morning, the light soft and diffuse. And West had all the time he needed.

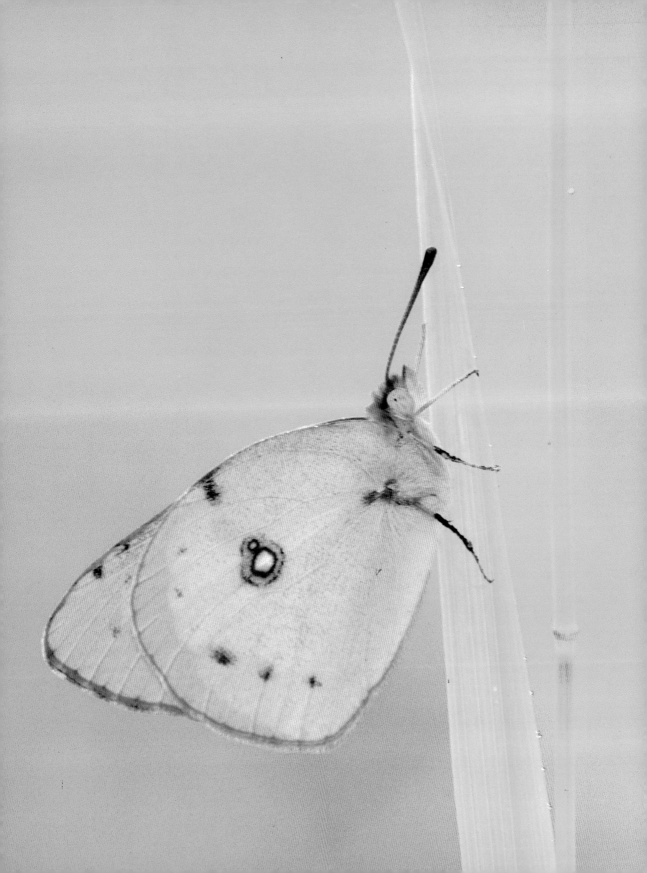

Making photographs of insects chilled and folded in the morning dew is gratifying and pleasant. Making photographs of moving insects, free-flying and feeding, is among the greatest of photographic challenges.

West likes a challenge. The large swallowtail butterflies, when nectaring, move constantly. For every good photograph he has made of them, West has spent many, many hours in the field pursuing them. It is always his object to move his camera's film plane as parallel to the plane of the butterfly's wings as possible. That, of course, means hand-holding several pounds of equipment in uncomfortable positions, moving with dancerlike grace and control, hoping desperately that the butterfly holds still for just a few more critical moments, and beginning again when it doesn't.

Tiger Swallowtail (Pterourus glaucus)
200mm macro lens with 3T close-up lens, electronic flash with flash compensation set at + 0.3, 50-speed film, 1/250 sec., f/16, handheld.

He's getting up, squatting down, inching ahead, stepping back, holding his breath, reaching forward, moving from flower to flower, completing hundreds of deep knee bends each butterfly day.

West learned here how to let sleeping bumblebees sleep through a photo session. Where do bumblebees sleep at night? This one slept hanging under a flower shelter. West found this particular bee one evening behind his house and went out the next morning to get it on film with morning backlight. Everything went perfectly as he set up his equipment and moved a reflector into place to bounce sunlight onto the bee.

But the minute the warm light hit the bee, it began to wake up and move. West pulled the reflector away and went back to his house for his flash. Using fill flash—just a bit of light to fill in the shadows—gave him good lighting without further disturbing the bee.

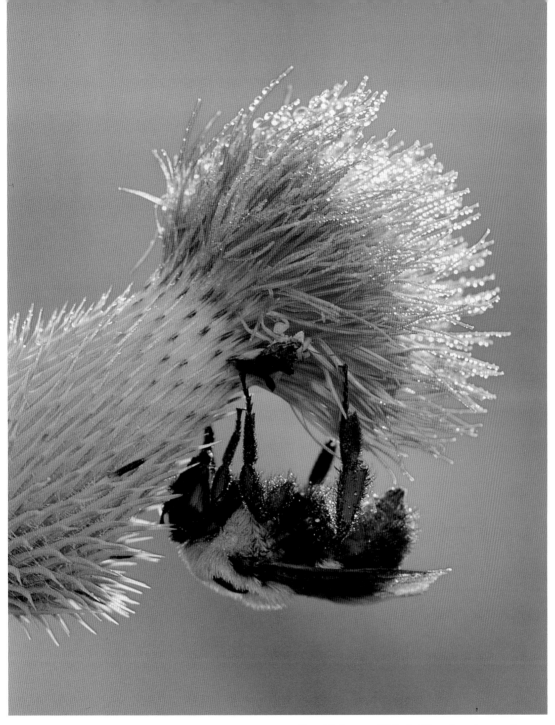

*Bumblebee on Thistle (*Megabombus *sp.)*
200mm macro lens with TC 14B multiplier, elec-
tronic flash with flash compensation dial set at
− 2.0, 50-speed film, 1 sec., f/11, on tripod.

West knows spiders, likes them, understands them. He spends a great deal of his time in company with them. Enough that he can predict spider behavior. He knows a whole lot more about spiders than most people would bother to know, which makes a difference in his spider portraits.

This is one of his favorites, of the burrowing wolf spider, *Geolycosa*. This handsome creature

Burrowing Spider at Burrow (Geolycosa turricola)
200mm macro lens with 3T close-up lens, at TC 301 multiplier, electronic flash with flash compensation set at +1.0, 50-speed film, 1/250 sec., f/16, on board pod.

gets its name from the Greek words *geo*, meaning "earth," and *lycosa*, meaning "wolf." Earth wolf spiders, or burrowing spiders, are wolf spiders that have legs modified for digging. This spider spends almost its entire life in a burrow it excavates in sand or other soils. At night it comes out to hunt in the area around its burrow for prey, but it stays within sight of its home. The female spins her egg sac within the burrow.

They sense vibrations in the ground and scamper down deep, so it's unusual to see one. West discovered that although they spend most of their days at the bottom of the burrow and sit in the mouth of the burrow at night, there are times when they change their behavior. On sunny days that follow a few days of rain, the spiders will sit in the mouths of their burrows, sunning and drying out, as this spider is doing.

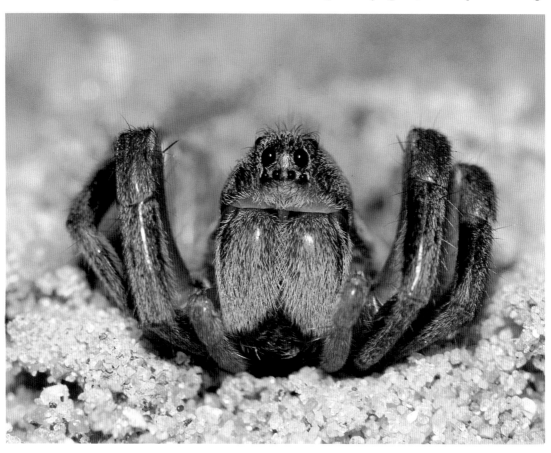

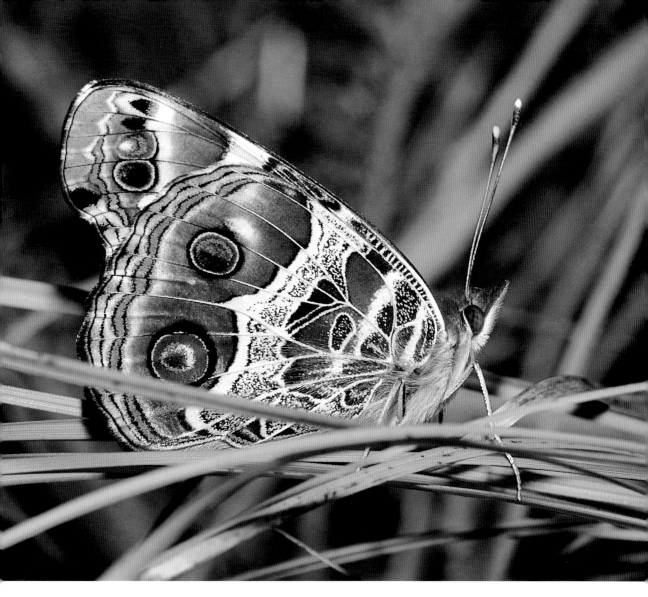

American Painted Lady (Vanessa virginiensis) *200mm macro lens with 3T close-up lens, electronic flash with flash compensation dial at + 0.3, 50-speed film, 1/250 sec., f/16, handheld.*

Which insects catch West's eye? They don't have to be rare species. They don't have to be flashy species. Just a species special for one of a million reasons an insect species *can* be special.

The American painted lady butterfly is one of West's favorites, for no particular reason other than that he rarely sees them. For all his time in the field, the American painted lady is one butterfly he's never seen locked in dew on a cool morning or sleeping in the meadow grasses. They're common throughout most of North America, but they just don't seem to flutter by West.

So on those rare occasions when he does encounter one, it's cause to celebrate. And he uses all the equipment and stalking skill in his power to get a photograph.

West keeps up with his studies as a naturalist and enjoys recording the behaviors he reads about in the scientific literature. Here, he's recorded ants meeting and "sniffing" one another, through the scent organs in their antennae.

People rely on sight and to some extent sound to recognize one another. Many insects have rather poor eyesight and communicate through other senses, particularly smell. These two ants are meeting at a busy intersection. Smell may provide them with a badge of recognition.

Researchers believe that insects, especially ants, wear a scent uniform. Every species of ant has a different odor, and every nest of ants has a distinct odor within the species, which can be recognized easily by individuals from that particular nest.

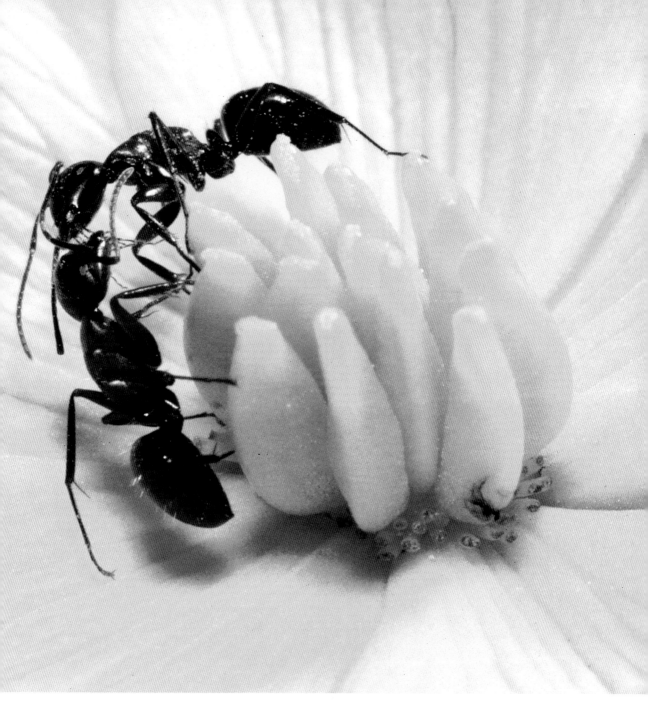

*Ants on Marsh Marigold Blossom (Family For-
micidae)*
*105mm macro lens with added extension, elec-
tronic flash with flash compensation dial set at
+ 1.7, 50-speed film, 1/250 sec., f/16, hand-
held.*

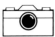

Photographics

Exposure

The first great challenge for a beginning photographer is understanding and using a camera's exposure controls to make a photograph. Even seasoned photographers occasionally get lost in the exposure soup. If you begin to feel any of this anxiety, you can dissolve it by learning and working with these four photographic truths: 1. The camera can't think. It's a *tool* you use to record the picture *you* want on film. 2. In any given photographic moment, there is *one amount of light.* Just one. It's your decision how you'll use it. 3. Your meter doesn't see color or recognize objects. It sees and records *tonalities.* 4. Modern cameras are factory-calibrated to record what your meter reads as a *medium tone.*

Within these four truths lies the best argument I can think of for not relying on your super camera's super automatic exposure controls. The camera can't tell that you're photographing whirligig beetles above a dark pond bottom. It only sees a lot of darkness. Left to its own devices, it will lighten that pond up for you, making it a medium rather than dark tone, and will lighten your beetles right out of recognition. The result is an overexposed photo-

graph. Learn to see the tones and think in tones, and good exposures will follow.

Reciprocity

Photographers describe exposure settings—various apertures and shutter speeds—in *stops.* To "stop up," or "open up," means to widen the aperture or slow down the shutter speed to allow more light to reach the film. "Stopping down," or "closing down," means narrowing the aperture or speeding up the shutter speed to allow less light to the film.

Each stop increment, in either aperture size or shutter speed, is always double the previous or half of the next stop value. So in shutter-speed sequences, 1/60 of a second is two times faster than 1/30 (we say one stop faster) and a 1/15 of a second is two times slower than 1/30 (one stop slower).

Aperture stops work the same way, but because we're dealing with the size of the hexagonal opening that lets light to the film, the numbers look a little strange—f/2.8 lets in twice as much light as f/4 (one stop faster), while f/5.6 lets in half as much light (one stop slower).

We balance aperture and shutter-speed stops to create different kinds of photographic effects

300mm lens with PN-11 and PK-13 extension tubes, 25-speed film, 1/30 sec., f/8, on tripod. (Heliconius charitonius)
Nectaring on shepherd's needles, these zebra longwing butterflies are a study in contrast. From the whitish of the flower blossoms to the darkest black of the wing stripes, this photo illustrates the extremes of the tonal range that can be captured by color slide photography. By metering off the medium-tone leaves, I retained as much of this extreme tonal scale as possible.

60

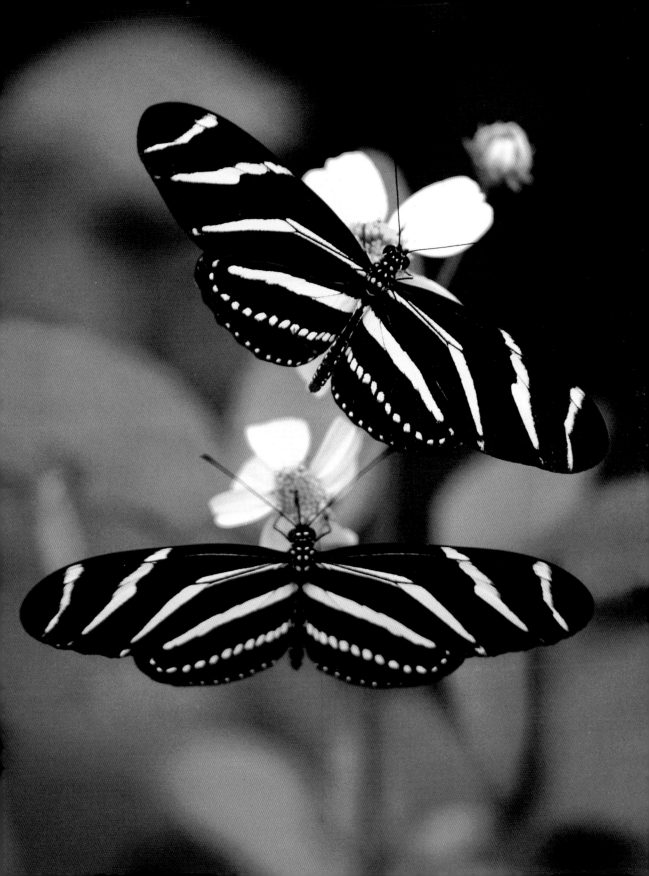

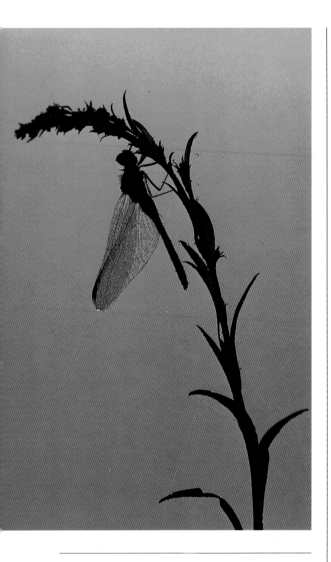

*200mm macro lens, 25-speed film, 1/4 sec.,
f/11, on tripod.*
(Sympetrum *sp.*)
*A dragonfly at sunrise. This looks like a diffi-
cult exposure, but it's really quite simple. In
silhouette situations, I just place the tonality of
the background where I want it. In this case,
the background is a small lake, backlit by the
golden light of the rising sun. I metered off the
water and opened up by one stop, knowing
this would place the background at light—just
what I had in mind.*

while recording a given subject. This balancing
act, or *reciprocity,* is easier to grasp with a
camera in your hands than it is just reading
about it in a book. If reciprocity is new to you,
now is a good time to pick up your camera to
use as a reference for the rest of this section.

In any scene, at any given moment, there is
one amount of light bouncing off your subject.
It is either natural light or light you've supplied
with a flash (see Natural Light and Flash on
page 79). You will use your camera's meter to
measure that light and discover the *base expo-
sure* for your photograph. This base exposure
determines the amount of light available to
your camera. If you open up your aperture one
stop *and* close the shutter speed down one
stop, your camera receives exactly the same
amount of light as it did for the base exposure.
Closing down the aperture by one stop and
opening up the shutter speed a stop also gives
your camera the same amount of light.

Now follow along with your camera in hand,
changing the settings as follows: Set your cam-
era at 1/60 of a second, and your aperture at
f/5.6. Now, move your aperture to f/4 and your
shutter speed to 1/125. Or if you choose, close
down your aperture two stops to f/11 and open
up your shutter speed two stops to 1/15. Get
used to these motions; they're what drives
reciprocity.

Sacrificing Speed for Depth

Why is reciprocity important? In considering
shutter speed, remember that faster shutter
speeds stop action. For subjects in motion, such
as dragonflies in flight, you need to use a fairly
fast shutter speed, or the subject will be re-
corded as an interesting but shapeless blur
across your picture. If you want to use a faster
shutter speed, and your camera needs more
light to register the photograph, you can get it
by opening up the aperture as you speed up the
shutter.

Smaller apertures, however, record more
focused distance, or *depth of field,* in your pho-
tograph. The larger the aperture, the more

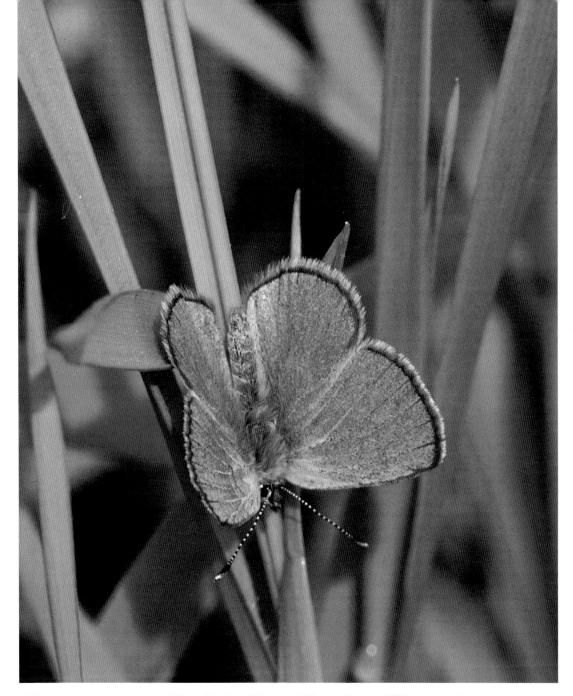

200mm macro lens with 1.4X multiplier, 100-speed film, 1/4 sec., f/22, on tripod.
(Glaucopsyche lydamus)
Drying dew-soaked wings in the first rays of the morning sun, this little silvery blue butterfly forced a compromise. This butterfly rarely spreads its wings flat, but keeps them at about a 45-degree angle. To keep the entire butterfly in focus would call for a very small aperture, which in turn calls for a very slow shutter speed. I used my tripod and exposed during lulls in the morning breeze. Several exposures brought one sharp one.

shallow your depth of field. Close-up photographers need plenty of depth, so they rarely use the very fastest shutter speeds; instead, they use flash to stop fast action. Natural-light photography is generally fine for large, still insects and butterflies in morning and evening postures. At these times, common exposures range from 1/4 of a second to perhaps 8 seconds long.

What Is Proper Exposure?

Let's redefine a couple of common terms. *Underexposure* happens when the exposure settings you choose produce a picture that is darker than you wanted it. *Overexposure* happens when the settings you select produce a picture lighter than you wanted it.

Proper exposure is achieved when you've set the camera's controls to record just what you want. Most photographers want a *literal translation* of the subject; they want it to look pretty much as it does to their eyes—no darker, no lighter.

Seeing Tones

The film you put in your camera is a primary dictator of exposure. As we've already pointed out, color slide film, because of its sharpness and versatility, is the norm in nature photography. Unfortunately, color slide film is also the most unforgiving in terms of exposure. One stop too much or too little exposure, and you just won't get a usable image.

Every picture has within it a range of distinct tones of lightness and darkness over which it can record the details of a scene. Photogra-

200mm macro lens with 1.4X multiplier, 100-speed film, 1/8 sec., f/8, on tripod.
(Argiope trifasciata)
In matters of depth of field, taste dictates. Here I chose to compose this banded argiope profile by placing my camera at a sharp angle to the web. I stopped the lens down just far enough to keep the spider in focus, and all else out.

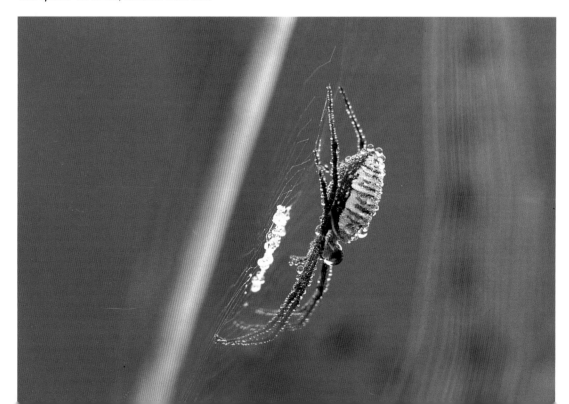

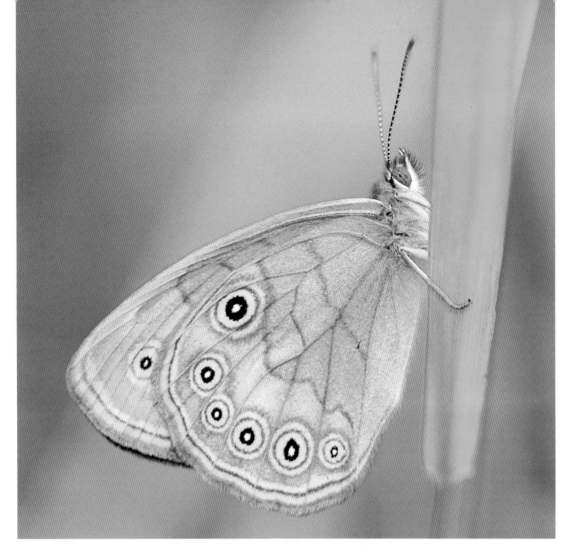

200mm macro lens with 1.4X multiplier, TTL electronic flash, flash compensation dial set at −2.0, 50-speed film, 1 sec., f/11.
(Satyrodes appalachia)
In the soft, even light along a forest edge, determining the exposure for this Appalachian brown butterfly was easy. I simply metered a portion of the medium green background that was in the same light as the subject.

phers distinguish several levels of tonality (Ansel Adams described these levels as "zones"), ranging from detailless light to detailless dark.

If this tonality stuff is beginning to sound confusing, let me make it more clear. Tones can be translated directly into exposure stops: *Each full tone is one stop lighter or darker than the next.*

It is common knowledge that slide films can record tonality over a range of only about five stops per film frame. That kind of thinking is confusing for many. Just remember this: You cannot record detailed black and detailed white in the same photograph. In high-contrast scenes, you'll have to compromise.

There are five tonalities I find easily recognizable and most useful in helping me determine exposure. They are as follows:

Whitish—Detailless white, such as snow without detail. The tone of the back side of a photographic gray card. Two and a half stops lighter than medium.

Very Light—The tone of fresh snow with detail, or a silk moth. Two stops lighter than medium.

Light—The tonal value of the skin of your palm, most yellow flowers, or most sands. One stop lighter than medium.

Medium—The tone of most green grass, the northern blue sky at sunny midday, or a monarch butterfly. The tone of a photographic gray card.

Dark—The tone of many tropical broad-leaved plants, old red oak bark, bison, or most dark beetles with sheen. Two-thirds to one stop darker than medium.

Because our eyes register color and automatically adjust for the range of tones they encounter with each glance, learning to see in tones takes a little practice. We tend to talk about tones as whiteness and blackness, which is misleading. Your camera reads the tonal range of all colors equally. For example, you can have medium red, light red, dark red, very light red, and so forth. Any color can be any tonality.

Using Tonality

Your camera's light meter, you'll be happy to know, isn't nearly as smart as you are. Metering systems on today's cameras range from not smart at all to very smart. All of them are very good at measuring light, but none of them can take the place of your photographic knowledge. When even the most intricate metering system takes a light reading of a snow scorpion fly teetering across the snow, it tries to find the happy medium.

Your camera doesn't know, unless you tell it,

that you want the scorpion fly to look like a scorpion fly. It sees only a vast tonal range from dark to whitish and seeks a compromise. But is it compromising on behalf of the snow or on behalf of the insect?

Understanding how your meter works is essential, but relying on your own ability to see and to think, then using your meter as a tool, is really the only way to ensure proper exposure. Remember, your meter will try to record the scene it's pointed at in a medium tonality. If medium is not a literal translation of your subject, you'll have to do something to make it the proper tone.

Here's how these exposure elements come together: You'll find your subject in the viewfinder, compose and focus, then take a base exposure reading. Now you ask the key exposure question: What tonality do I want to make this subject?

If you're out in the summer and spot a hornworm caterpillar on your tomatoes, you'll mount your camera on a tripod, then take a meter reading of the caterpillar and its background, the tomato plant. Both the hornworm and the background have medium tonal values, and you want them recorded literally in your photograph. This is the perfect condition for your medium-seeking meter. So you'll simply set your aperture dial to the stop setting suggested by your meter, and trip the shutter.

Finding a medium-toned tomato plant in the same lighting as your subject made that exposure easy. But medium tones aren't always available. That hornworm may crawl onto a pale green tomato, one stop lighter than medium. If the meter sees too much of the light tomato, it will try to make the tomato a medium tonality, and the picture will be underexposed. With a spot meter, you might be able to take a reading of the medium green caterpillar itself, and your camera would suggest a proper exposure.

But there's an easier way, if you'll let your knowledge of tonality take over. You know that the unripe tomato is light—one stop brighter

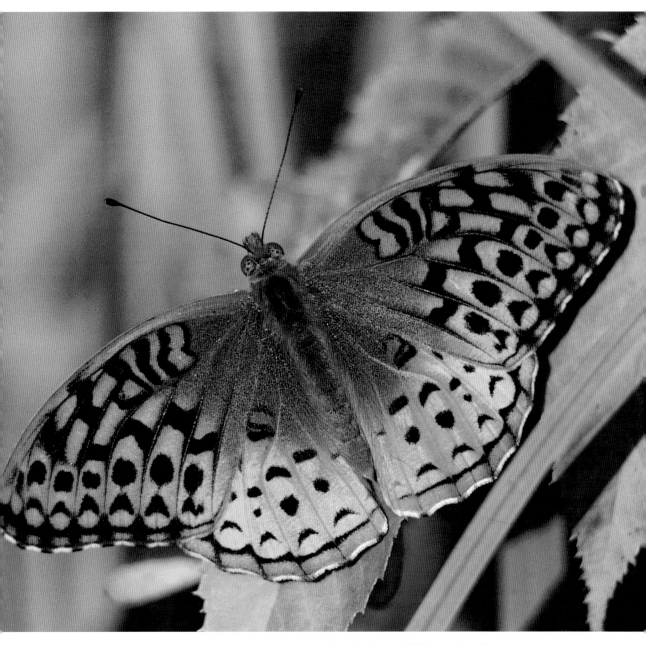

200mm macro lens with 1.4X multiplier, 25-speed film, 1/8 sec., f/11, on tripod.
(Speyeria cybele)
The great spangled fritillary is a swift flyer. This one paused a moment in the early sun. These butterflies inhabit moist meadows and deciduous woods. They fly where violets—their larval plants—grow. This exposure was easy to calculate, with a medium orange butterfly on medium green foliage.

67

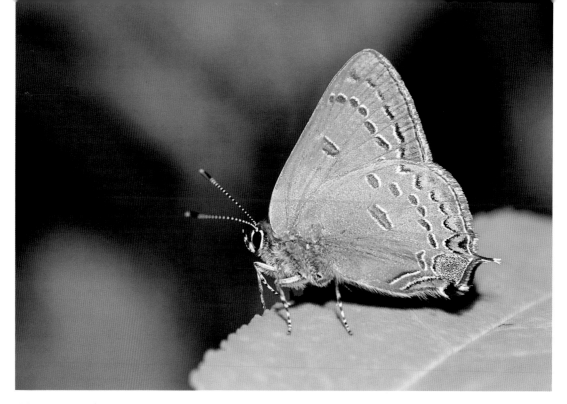

200mm macro lens with 3T close-up lens, TTL electronic flash, 50-speed film, 1/250 sec., f/22, hand-held.
(Satyrium edwardsii)
Single brooded, this Edward's hairstreak flies in Michigan's scrub oak clearings in July. Finding the exposure for this mostly medium subject was easy; I simply turned on the flash, and the camera did the rest.

than medium. You know your camera will try to make the tomato medium. So to get a proper exposure for the caterpillar, you simply take a reading of the tomato and "open up" one stop to compensate (because there's a one-stop difference between medium and light). So if the camera meter suggests a setting for the tomato of 1/60 of a second at f/11, you compensate by slowing the speed to 1/30 of a second or enlarging the aperture one stop to f/8.

Let's try it again. The hornworm falls down to the wet ground. Your camera wants to make the dark, wet ground a medium tone. You know the ground's tone is dark, one stop darker than medium. So you take a reading of the ground and close down one stop. Again, the caterpillar will be rendered in a nice medium green.

Tonal Tricks

Once you've become used to tonality, you can begin to appreciate the subtle effects you can achieve at the ends of the tonal scale.

I advise my students to "expose for the light tones" in slide photography. That means concentrating on the lightest tones of your subject and stopping down *just enough* to preserve detail in the highlights, but not so much that you end up with muddy images. For instance, if I were photographing a white moth against dark bark, I could meter the dark background and close down one stop to get a literal translation of the bark. But my subject is the moth, which is very light. So instead of using the exposure I just calculated, I'll close down one-half stop more, to give me better detail in the moth's

wings. If I could fill the meter area with the moth (a spot meter is nice for this), I could place the moth as very light by opening up two stops. Both techniques will give me the same exposure.

I have to remember that when I do this, I also change the tone for the rest of the scene. In this case, the bark may drop down to almost detail-less dark, and that would make a pretty uninteresting picture. I like to photograph both very light and dark subjects earlier or later in the day, or when the sky is overcast, when the lighting is more shadowless and diffused and the tonal range easier to handle. Or I choose a subject on a background of a lighter tone that will look all right in a darker tonality.

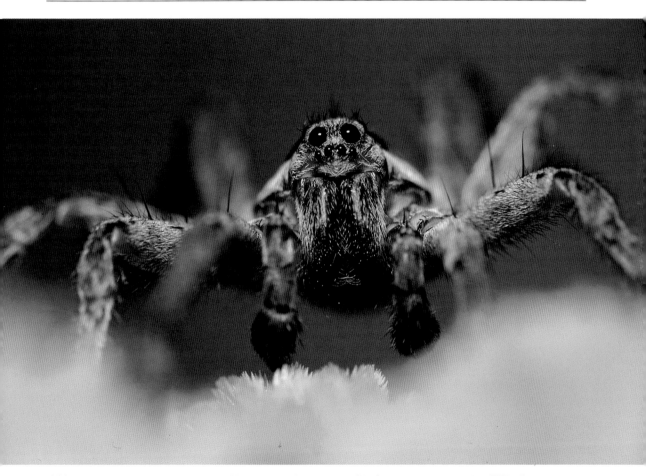

200mm macro lens with 4T and 3T close-up lenses and 27.5mm extension tube, TTL electronic flash, 50-speed film, 1/250 sec., f/22, hand-held.
(Lycosa gulosa)
A hand-holdable, compact flash setup is great for exploring in uneven terrain. In this case, I found this wolf spider moving about over mossy hummocks, stopping in places no tripod-mounted camera could reach. The medium-toned subject called for a zero setting on the camera's compensation dial.

69

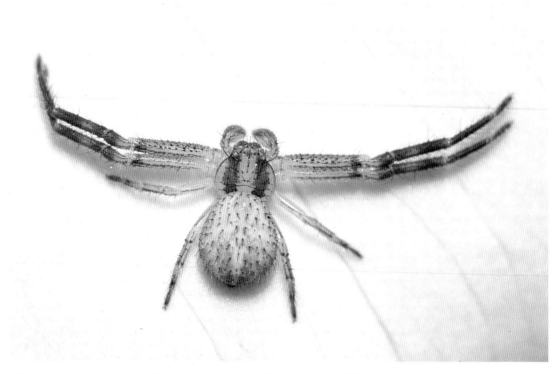

200mm macro lens with 4T close-up lens and 2X multiplier, TTL electronic flash, camera compensation dial set at + 2.3, 50-speed film, 1/250 sec., f/22, on tripod.
(Misumenops asperatus)
For this crab spider on a trillium blossom, I calculate the same flash exposure I would give a light subject on the snow, opening up 2⅓ stops.

But let's say you're interested in making the bark darker than you see it, or making a luna moth more lunar. Now you have another kind of choice. Perhaps you want your pond water more blue, more saturated, than it actually appears. If so, close down a half-stop. Or do you want the fog foggier? Open up a half-stop. In this case you may move a little away from a literal translation in order to give more feeling to the scene. It's your choice.

Working in Automatic
If you prefer to use your camera on automatic, certainly feel free to do so, but it's helpful to

understand tonality and reciprocity to know what your camera can and cannot do for you.

When working in automatic, use your compensation dial to make up for your camera's medium-seeking tendencies. If your subject is one stop darker than medium, dial in a minus stop on your camera's compensation dial. If it's two stops lighter than medium, dial in two plus stops.

Remember Who's in Charge
Remember that you're the photographer. Your camera is a tool. Despite popular belief, there is very little hocus pocus involved in getting good

exposures. You make the decision to record things as you see them or as you'd like to see them. Take the time to learn the tonal system. Practice, practice, and those decisions will come more quickly.

Magnification

Close-up photographers have a number of means for getting the big picture. If you'll recall from the equipment section, close-up subjects create a push-me/pull-you effect when the

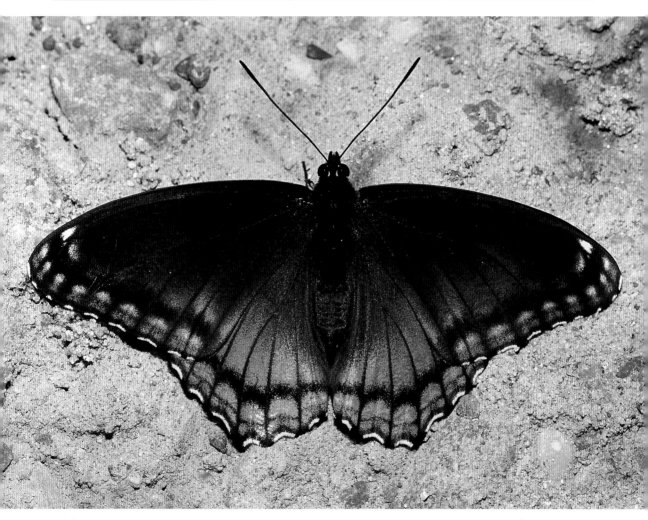

105mm macro lens, TTL electronic flash, camera compensation dial set at + 0.7, 50-speed film, 1/250 sec., f/16, hand-held.
(Basilarchia Astyanax)
The dark blue of this red-spotted purple can be misleading. If you had a spot meter and spotted on the dark blue portions of the wings, you would want to give minus exposure. But with center-weighted metering, the light blue on the wings and the light sand surrounding the subject influence the meter. I actually dialed in + 0.7 stops for this exposure.

time comes to choose optics. Telephoto lenses by themselves can't focus closely enough for many close-up subjects. Even macro lenses are limiting when your subjects are insects, spiders, and their kin—such as the tiger swallowtail larva at right.

The most popular macro lenses will allow you to reach half life-size, or a 1:2 magnification ratio. On 35mm film, a half life-size image records an area that is 48 × 72 mm, or 2 × 3 inches. Life-size records an area 24 × 36 mm, or 1 × 1.5 inches (the size of a 35mm slide), still a lot of space for many insects and spiders.

In the old days, the best solution for increasing magnification was to add extension tubes or extension bellows to move the lens away

105mm macro lens with PN-11 extension tube and 4T close-up lens, TTL electronic flash, camera compensation dial set at + 1.0, 50-speed film, 1/250 sec., f/16, hand-held.
(Family Formicidae)
Ants are incredibly strong. This one hauled this grasshopper leg up a 45-degree loose sand slope. By combining extension with a close-up lens, I made a compact, easy-to-hold setup for following my subject and constantly recomposing.

from the film plane, allowing a larger image to be recorded on the film. This worked, but those tubes and bellows made equipment bulky and awkward in the field. Another popular method in days when we didn't have the high-quality, affordable optics we have today was stacking lenses: mounting lenses back-to-front to get high magnifications. These combinations restricted you with very short working distances.

Today I find these methods unnecessary, preferring instead to combine a high-quality, long macro lens with multipliers and multi-element close-up lenses. For instance, I screw a Nikon 4T close-up lens to the front of my 200mm macro to bring me to a little more than life-size (1:1). If I need still greater magnification, I add a 2X multiplier behind this combination to reach twice life-size (2:1). At this magnification I can photograph very small creatures, like mosquitoes and ladybird beetles, full frame with a

working distance of around 8 inches—which is terrific for close-up work.

This optical configuration is one of several I've used over some thirty years of photographing insects. With today's optics there are many lens combinations you can use to get the magnification you want (see Figure 3-1). As you purchase new or used equipment for close-up work, always buy with flexibility in mind. If you shop carefully, a few pieces of optical equipment can prepare you for virtually any photographic opportunity. I own a lot of equipment but carry only a few pieces on any given field trip. This equipment, usually one prime lens, one or two close-up lenses, two multipliers, and a couple of extension tubes, has become as familiar to me as my favorite jeans. I know what it can do, and I know what it can't do. The following are some ways to achieve the magnifications you want.

Figure 3-1

Magnification Table

Magnification	Area Covered	Subjects	Equipment
1:4 to 1:2	96 × 144mm to 48 × 72mm	Large butterflies Moths Dragonflies	80–200mm zoom with + 1.5 close-up lens 75–300mm zoom with + 1.5 close-up lens 200mm macro 105 mm macro Standard telephoto with close-up lens Standard telephoto with extension tubes
1:2 to 1:1	48 × 72mm to 24 × 36mm	Small butterflies Honeybees Wolf spiders	80–200mm zoom with + 3 close-up lens 75–300mm zoom with + 1.5 close-up lens 75–300mm zoom with + 3 close-up lens 200mm macro with + 3 close-up lens 200mm macro with + 1.5 close-up lens and 1.4X multiplier

Figure 3-1 (continued)

Magnification Table

Magnification	Area Covered	Subjects	Equipment
1:2 to 1:1 (continued)			200mm macro with 2X multiplier Some 105mm macros 105mm macro with added extension 105mm macro with + 1.5 close-up lens 105mm macro with 1.4X multiplier 105mm macro with 2X multiplier Standard telephoto with extension, close-up, multiplier, or some combination of the three (Can be hand-held)
1:1 to 2:1	24 × 36mm to 12 × 18mm	Small wasps Ladybird beetles Many other small creatures	105mm macro with 2X multiplier 105mm macro with + 3 close-up lens and 1.4X multiplier 200mm macro with + 1.5 close-up lens and 2X multiplier 200mm macro with + 3 close-up lens and 1.4X multiplier (Some equipment combinations can be hand-held; do run tests before fieldwork)
2:1 to 4:1	12 × 18mm to 6 × 9mm	Mosquitoes Toad bugs Savage beetles	105mm macro with + 3 close-up lens and 2X multiplier 200mm macro with + 3 close-up lens, 79mm extension, and 2X multiplier (These magnifications require support)
4:1 to 8:1	6 × 9mm to 3 × 4.5mm	Snow fleas Insect-egg wasps	200mm macro with two + 3 close-up lenses, 50mm extension, and 2X multiplier (These magnifications require support)

Diffraction

Diffraction—unsharp images due to the bending of light around the edges of a lens's diaphragm—at small f stops intensifies at magnifications around life-size and grows progressively worse at higher magnifications. Some optics and combinations are much more prone to diffraction, preventing you from using the smallest apertures on your lenses. The problem comes as you move your aperture farther from the film plane by adding extensions, or as you optically reduce your aperture's size by using multipliers.

Photographing at life-size with my 105mm macro lens with added extension, I've found that f/11 is the best aperture, giving me razor-sharp images. If I stop down to f/16, I still get good quality with a little more depth of field. If I go to f/22, the images are noticeably less sharp, and at f/32 I get mush. At half life-size (which requires less extension), I get good results at f/22.

Now with a 200mm macro and a 4T close-up lens plus a 2X multiplier, I achieve best results at f/22 even at a magnification of twice life-size. Closing a lens to its smallest f stop is usually counterproductive to obtaining optimal optical results.

But again, test your equipment to find out what its limitations are and what your smallest apertures can be with various lens and accessory combinations.

200mm macro lens with 4T and 3T close-up lenses and 2X multiplier, TTL electronic flash, camera compensation dial set at + 0.3, 50-speed film, 1/250 sec., f/16, on tripod.
(Family Dolichopodidae)
A long-legged fly pauses on the edge of a wild grape leaf. Most species of these small to medium-sized flies are fiercely predacious. This 6mm creature preys on even smaller insects and mites. Males of some species perform complex mating dances for the females, displaying fans or disks of bright leg scales.

Using Close-up Lenses

Close-up lenses are, in my estimation, the most user-friendly equipment in my bag. They have suffered a bad reputation in the past because the older-generation close-up lenses—simple, single-element instruments—were optically limiting, almost never resulting in the razor-sharp images we look for today.

But today's two-element lenses are fabulous. Produced by most of the major manufacturers—Nikon, Canon, Minolta, and Leitz, as well as some after-market houses—they're lightweight, compact, and easy to use. These lenses, like filters, screw onto the front end of your prime lens. They don't diminish the light reaching the film, and the viewfinder image stays as bright as it would with the straight lens. They're available in a number of sizes. Nikon makes two sizes, with two strengths in each size. Century Precision Optics makes high-quality, if pricey, close-up lenses in two sizes, which are especially good for people using large-aperture zooms.

Close-up lens power is measured in magnification, or diopter powers: $+1$, $+2$, $+3$, etc. These lenses will bring you to a given working distance from your subject, regardless of the focal length of your primary lens. A $+3$ lens will bring you closer to your subject than a $+2$. To gain magnification while keeping as much working distance as possible, attach your close-up lens to a longer prime lens. I most often use a 200mm macro lens as my prime lens. This length gives me much more versatility in the field than a 105mm macro. For instance, if I can get half life-size, or 1:2, with a close-up lens on a 105mm macro lens, that same close-up lens on my 200mm macro would give me life-size, or 1:1. I get a larger image for the working distance, and I keep myself and the camera out of the way of the light source, whether natural or flash.

Keep in mind that adding a close-up lens decreases the effective focal length, making the lens combination easier to hand-hold. This can be an advantage when working with flash, because when the flash and lens are closer to the subject, the light has more intensity, allowing smaller apertures. I commonly use a Nikon 3T on the front of my 200mm macro, giving me a range of coverage from roughly 77×111mm to 27×41mm—just right for most butterflies.

One of the most versatile lens packages for the discerning amateur close-up photographer is an 80–200mm zoom with a $+3$ close-up lens. This combination will give a photographer great flexibility while exploring outdoors, with magnification capability from 1:4 to life-size, with the help of a little lens you can carry in your pocket.

Close-up lenses can be stacked to increase their power. A Nikon 3T and 4T become a $+4.5$ diopter. Stacking these lenses works better on some primary lenses than others. For example, on my 200mm macro, the quality is low, but I have found a way to improve this. Spacing the lenses 8mm apart by using an old filter ring greatly improves the quality and is well worth trying on other lenses.

With my 200mm macro, I use both close-up lenses in reversed position. On some lenses, the close-up lens needs to be reversed. I don't know why, but it works. So far the only lens I've found that requires this is the 200mm Micro Nikkor. On this lens, the close-up lenses are poor in normal position but superb when reversed. Normal position is great on the other macro lenses I have tried, as well as with zooms. You can reverse lenses by using a male-to-male ring available from Kirk Enterprises (see Resources).

Using Multipliers

When I'm looking for an image that's larger than life, as when I want to create an up-close and personal portrait of a fruit fly, I increase my magnification still further by attaching a multiplier between my camera and my prime lens.

I use multipliers a lot. They give me greater working distance and a lot of flexibility. In the field, if I've mounted a multiplier to my 200mm macro, I can quickly change from photograph-

200mm macro lens with 4T and 3T close-up lenses and 2X multiplier, TTL electronic flash, camera compensation dial set at +2.0, 50-speed film, 1/250 sec., f/16, on tripod.
(Mordella octopunctata)
Tumbling flower beetles spend most of their lives on the blossoms of flowers. When disturbed, they kick and tumble about, hence their common name. To photograph this beetle as it feeds on the umbel of Queen Anne's lace, I doubled up on close-up lenses and added a 2X multiplier to my long macro lens, giving me high magnification at a good working distance.

ing a grasshopper to catching a portrait of a passing deer or the sunset without having to remove any device from either the front or the back of my primary lens.

A multiplier, or tele-extender, does what its name suggests: It multiplies the focal length of the prime lens. A 2X multiplier attached to a 200mm lens yields an effective 400mm lens. A 1.4X multiplier on the same lens results in an effective 280mm lens.

Multipliers also multiply (therefore diminishing) the effective aperture. This costs you light. For instance, if you have a 200mm primary lens that opens to f/4 at its widest aperture, adding a

200mm macro lens with two 4T close-up lenses and 2X multiplier, TTL electronic flash, camera compensation dial set at + 1.0, a small flashlight, 50-speed film, 1/250 sec., f/16, on tripod. (Family Tephritidae)

A 5mm-long fruit fly feeds on the cap of a fly amanita mushroom. These colorful little flies walk about rhythmically waving their wings up and down, giving them the alternate name of peacock flies. The larvae of most species feed on flowers, fruit, or fungi. By combining close-up lenses, I manage a high magnification while keeping the equipment reasonably compact. A small, flexible flashlight attached to my flash bracket provided the extra focusing illumination I needed in the dim forest light.

2X multiplier would effectively change that aperture to f/8. If you started at f/4 with a 1.4X multiplier, you would end at f/5.6.

Finally, multipliers increase the magnification in your close-up work, also by the power of the multiplier. If you're working at life-size (1:1) with your current rig, attaching a 2X multiplier to the camera behind all your other close-focusing equipment would bring your image to twice life-size (2:1) without changing your working distance. However, because the focal length of this rig has increased, hand-holding becomes more difficult. I like to use multiplier setups on sturdy supports.

Using Extension

In my early days, I relied heavily on extension tubes as the means to good close-up photographs. Today I rarely use them and don't usually recommend them. Despite their drawbacks, however, they do remain a good and particularly cost-effective method for increasing magnification.

Extension tubes increase magnification by moving the lens or lenses farther from the film. These tubes can be very simple, inexpensive devices that you can buy singly or in sets. (A bellows is another form of extension, but for many reasons it is less practical for fieldwork.)

When buying extension tubes, be careful that you find ones that do not disconnect the camera-to-lens metering and automatic aperture control connections.

I add short extension tubes to my close-up lens setup when I need just a bit more magnification, or in combination with close-up lenses and multipliers when I need every bit of magnification I can get. They also work well on my old 105mm f/4 macro, which was designed to reach 1:1 by means of added extension.

Natural Light and Flash

It's easy to photograph a sleeping insect, a dew-covered dragonfly, or a wet-winged butterfly on a windless morning using natural light. Mornings are the natural equivalent of chilling an insect in a refrigerator. (I firmly believe that capturing and refrigerating subjects is ethically wrong and certainly not a way to record natural behavior.)

But then the sun comes out. And that dragonfly or butterfly becomes terribly busy, moving from perch to perch, flower to flower. And you've got problems: Mobility problems. Speed problems. Aperture problems. If small, active creatures are the problem, electronic flash is the answer, getting light and speed where you need it when you need it to make your photograph.

Is All Light Good Light?

Light—it's the "photo" in photography. Photographs can't happen without it. The intensity, consistency, color, constancy, and direction of light preoccupy photographers of all kinds all the time. Outdoor photographers have a particular preference for natural, or *ambient*, light of nearly any kind, with the most votes going to *diffused* ambient light. The light of a bright, cloud-covered day sends us heading for the fields.

Direct frontal or side light from the sun can bring out hard lines and shadows, brighter brights and darker darks. This is *high-contrast* light. Harsh, direct light also widens the range of tonalities, often making a wider range than color slide film can record. Diffusing this light softens the contrast, revealing the rich colors and fine details in a scene. When you photograph insects, spiders, and such, you're looking for that detail and color. Diffuse bright sunlight by filtering it through a white photographic umbrella or, as I do, through a collapsible diffusion disk. Diffusion will make harsh light perfect for subjects still enough or patient enough to wait while you set up the lighting.

Light coming from the wrong direction can be both diffused and redirected into your composition if you use a reflector. These units are handy and easy to pack. But again, they only work if you've got the time and your subject will wait.

When You Need More

Whenever possible, I make my insect photographs using ambient light—not because I'm a purist about natural compositions, but because natural light can be very beautiful, and I don't want my equipment to be any more complicated or cumbersome than it absolutely has to be. I use flash when it's appropriate, which is quite often when photographing insects and spiders.

Today's flashes are nothing like the flash bulbs I grew up with. Flashes today are battery-powered, often computer-chip-driven machinery. Some are complicated and "smart"; others are incredibly simple. These electronic flashes deliver very short, bright flashes of light. With many 35mm camera through-the-lens (TTL) flash systems, the amount of light and the timing of the flash are controlled by the flash and camera. The equipment works together to synchronize the flash of light with the opening of the shutter so that the correct amount of light will reach the film plane to expose the subject. They're terribly easy to use and require precious little calculating or maneuvering to achieve stunning effects.

If your camera doesn't allow for TTL flash metering, don't despair. Learning how light works and what your equipment can and can't do is not exactly rocket science. Once you've learned how to do it, it makes sense—it's only while you're learning it that it may seem impossible. Read on.

The Inverse Square Law

When you understand the way light travels, flash photography begins to make sense.

As the short burst of light leaves a flash, it spreads outward. As the light spreads to cover a wider area, its power to illuminate any given portion of that area lessens. That is, the farther away the flash, the wider the area it covers but the dimmer it becomes. We say the light "falls off."

This movement of light happens in a very predictable pattern described by the "inverse square law," which simply states that light will "fall off" to the square of the distance it travels. So if a flash illuminates a certain area 1 foot away, at 2 feet away that same amount of illumination will spread out to cover four times the area.

At double the distance, you can also think of the light as being *two stops* less bright. If you double the distance again, moving the light to 4 feet, you will weaken the light by another two stops, making the light intensity four stops less at 4 feet than it was at 1. So the farther you place your flash from your subject, the less intense the light will be as it reflects off the subject to record its image on film.

Conversely, the closer the flash is to the subject, the more intense the light. Flash photography really comes into its own when you're photographing tiny creatures up close. The sun is a very large light source, a long way away. Flashes are comparatively tiny light sources when photographing people. And many people dislike the quality of flash light, because the small source is harsh and produces deep shadows. But proportionally, using a 4-inch flash unit for, say, a harvest mite crossing a log at 3:1 magnification would be like photographing a person with a softbox the size of a studio

(Top) 200mm macro with 1.4X multiplier, 50-speed film, 1/8 sec., f/11, on tripod. (Bottom) 200mm macro with 1.4X multiplier, TTL electronic flash with flash compensation dial set at −2.0, 50-speed film, 1/8 sec., f/11, on tripod.
(Libellula pulchella)
I like a subtle fill flash. To illustrate fill flash capability, I took the photo on the top using no flash. On the bottom, I added a weak fill just to bring a few highlights to the wings and open the shadow under the head a bit.

81

200mm macro with 1.4X multiplier, TTL electronic flash with flash compensation dial set at −2.0, 50-speed film, 1 sec., f/11, on tripod.
(Euphydryas phaeton)
At the north edge of my woodlot is a wet meadow where a plant called turtlehead grows. Turtlehead is the larval food plant of the Baltimore checkerspot. One June evening I was not surprised, but delighted, to find this mating pair. The evening's stillness made long exposures possible. I added a weak fill flash for a bit more sparkle.

wall. The light is beautiful, even, diffused. And when the light is close and intense, you can use smaller apertures, which give you greater depth of field.

Total Flash and Fill Flash

I like to reduce flash photography discussions to my two most general applications: total flash and fill flash.

Total flash provides artificial light brighter than the ambient light you're working in. In total flash, the flash provides all the light used to record the photograph. That is, total flash completely overpowers the ambient light.

Fill flash "fills in," to put light into a shadow or illuminate a subject backlit by a stronger light. Fill flash plays junior partner to the ambient light.

When to Use Total Flash. I prefer total flash when my subject and its background are on a

single plane. If I'm photographing a honey-comb, I can light the whole composition with the flash. Or I might use total flash when the background is fairly close or can be easily lit using a second flash unit. Total flash is also handy for situations in which there is simply no light, as in photographing singing insects at night.

When to Use Fill Flash. I have a strong preference for fill flash effects. I like to add fill flash when the ambient light is handing me a nicely lit background. I use the fill to give my subject crisp detail, with perhaps a nice high-light in the eye. Fill flash is natural light plus.

Fill flash simply *fills in* where daylight leaves off. You don't always need it, but it sure comes in handy when you want to open up a shadow, show off the texture of a moth's back, pull out the iridescence of a butterfly's wing, make the dew on a bumblebee really stand out, or illus-trate the translucence of a larval case.

To keep the beautiful natural light, you have to avoid swamping it. That means you have to provide less light—one or two stops less—than that which is being provided by the sun.

Equipment

Flash photography is as easy as you can afford to make it. The technology improves daily, get-ting easier to use and less expensive. There is nothing wrong with using the good old equip-ment I used ten, fifteen, thirty years ago. But frankly, when I'm in the field working, I want to think harder about my subject and composition than I do about my flash equipment, lighting ratios, inverse square laws, and such. I'm glad I understand all that stuff, though—it makes shopping for new equipment easier.

At this writing, my most often used flash for close-up work is a Nikon SB-24. I use this most frequently on a flash bracket, mounted at a 30-degree angle above the lens, connected by an SC-17 flash cord. The angle allows an open, more natural light than I could get if I left my flash mounted on the hot-shoe of my camera.

I bought the SB-24 because it's simple to use, works well with my other equipment, and has all the features I'm looking for in a flash. It's smart, as some flash units are these days; it has TTL exposure-setting capabilities, rear-curtain synchronization, a zoom head, and a flash-standby mode, and keeps my batteries from draining as I look for little creatures. It has easy-to-use compensation adjustment, and it's a nice, compact size.

Flash Synchronization

Many 35mm cameras can synchronize the fir-ing of a flash with the shutter only at relatively slow shutter speeds, like 1/60 or 1/125 of a second. These speeds assure that the shutter will be completely open before the flash flashes. In total flash photography, the speed of the flash (1/500 to 1/100,000 of a second) be-comes the effective shutter speed. If your sub-ject is moving and there is enough ambient light about, you can end up with a ghost im-age—your wasp perfectly exposed in the posi-tion it held when the flash went off, over a hazy image of the wasp in its new position when the shutter closed. Synchronization speeds that ex-clude more of the daylight help minimize ghost-ing. The fastest synchronization, or sync, speed I've seen in a 35mm camera is 1/250 of a second.

Setting Flash Exposures

Before buying or using any flash unit, you should know precisely what it is capable of doing for you. The best way to do this is to test it yourself, particularly if you're working with manual rather than TTL flashes.

With manual flashes, the inverse square law comes into play; you'll need to test your equip-ment to know precisely which aperture setting will work best with your close-up lens and film combinations.

Total Flash with TTL. Electronic through-the-lens flash systems make total flash a breeze. TTL cameras contain a flash meter. When you

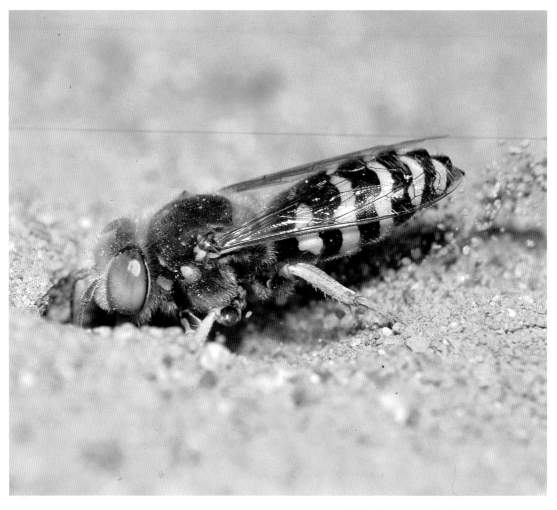

200mm macro lens with 3T close-up lens and 1.4X multiplier, TTL electronic flash, camera compensation dial set at + 1.0, 50-speed film, 1/250 sec., f/16, on board pod.
(Bembix americana spinolae)
Used up close, through-the-lens (TTL) flashes are fast. With the camera at its top synchronization speed, and the lens at a small f-stop, natural lighting is irrelevant. The duration of the flash provides all the light the film needs at super-fast speeds, in this case about a 5,000th of a second. Fast enough to stop the action of the sand wasp and the sand it kicks behind it.

attach your electronic flash to your camera's hot-shoe or dedicated off-camera cord and turn it on, this flash meter kicks in. Your camera tells your flash what it needs to know—what speed of film you're using, how much light it needs with the lenses and attachments attached. With your camera set to manual mode (I can't think of a single situation when I wouldn't set the camera to manual when using a flash), you set your shutter speed to the fastest flash-sync

speed your camera allows. You've memorized your camera's instruction manual by now, so I'm sure you know what your fastest flash-sync speed is.

Next, you set the aperture you'd like, probably a small one for greater depth of field. And you simply take your picture. The camera shuts the flash off as soon as it's given enough light for the aperture you've selected.

With TTL technology regulating the amount of light, all you have to worry about is the tonality you want in your final image. Your camera and flash are now in cahoots, still trying to record everything as a medium tone. This is where the compensation dial earns its keep. If your subject is light and you want a literal translation, use your camera's compensation dial to add one stop of light. If your subject is darker than medium, you should dial in a minus.

How much compensation you give will depend on the metering pattern you choose and the tonality of the area within the metering pattern. Spot metering is always the least influenced by tonalities surrounding the subject. Center-weighted metering is more influenced, and multisegment metering evaluates various parts of the scene to determine exposure. Used properly, any of these systems will produce excellent results. And the amount of compensation you should use will depend on your system. All of the photographs in this book were made with a camera that relies on center-weighted metering.

Total Flash without TTL. For total flash without TTL technology, choose a small flash—one with a guide number of around 40 for ISO 50 or 64 film. Next, pick a short telephoto lens, one in the 90mm to 135mm range, or a zoom that covers this range. Use the lens with extension to get the magnification you want.

Position the flash over the front of the lens and a few inches above it for nice, open lighting. Set your camera for manual exposure mode and the shutter at its highest sync speed. Pick your medium-tone exposure using the following chart for ISO 50 or 64 film.

Lens Size	Aperture
90mm	f/22
105mm	f/16–22
135mm	f/16

For 100-speed film, close down one stop from the apertures given in the chart. This works for subjects you're recording at 1:2 or closer. At 1:4, open up a half-stop. You may also need to open up or close down by half-stops for subjects that are quite light or dark. Tests will help you determine this.

Fill Flash with TTL. With fill flash, the main light source is the sun—the ambient light. The flash is secondary, opening up shadows or adding just a bit of sparkle to the subject by providing light that is one or two stops weaker than the ambient light.

Fill flash became easy when the smart flashes with compensation scales came on the scene. My Nikon SB-24 allows me to set the ratio of natural light to flash exposure. I determine my exposure by metering the subject in manual as I normally would to get a literal translation base exposure. Then I add a much weaker fill flash. The effect is much the same as a correctly positioned reflector would give me, but in less time, with less hassle, and with the ability to move quickly if my subject does. I also avoid disrupting my subject or anything around it.

The same control can be achieved with a TTL flash that has no compensation scale. With the camera in manual mode, determine the natural light exposure. Use this setting, and set the camera's compensation dial to minus one or two stops to control the flash.

Here's where rear-curtain synchronization becomes a very handy tool. Sometimes when the flash fires, your subject may blink or twitch slightly, just as we all do when we see a bright flash of light. If that twitch happens at the beginning of a lengthy exposure, you end up with a blurred exposure. If the flash fires at the end of the exposure, the shutter is closed before any movement takes place.

The difference between using fill flash and

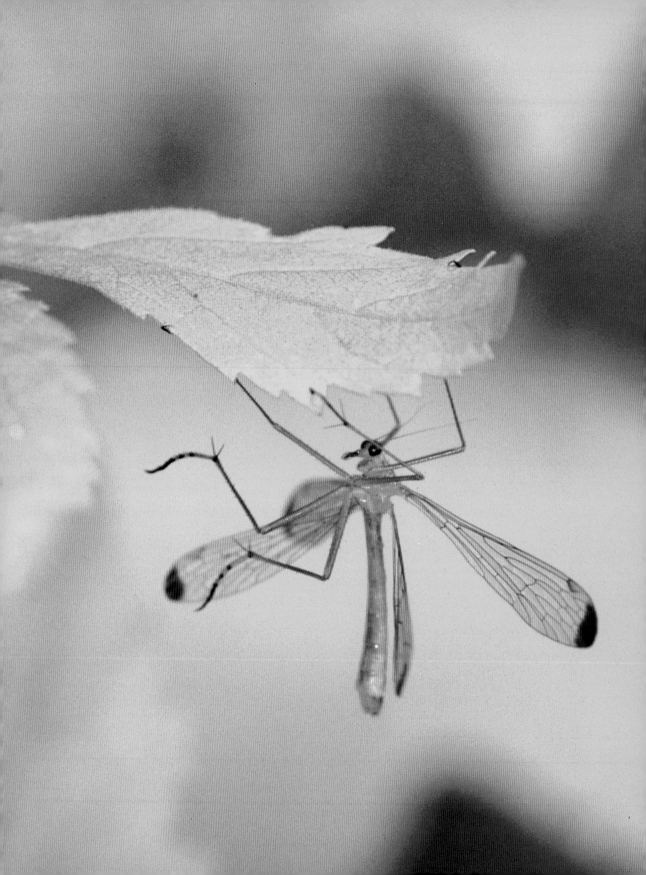

not using it can be very subtle. Important, but subtle. But be careful. It's very easy to get fill-flash-mania and find yourself applying it to the exclusion of exploring possibilities in natural light. It's a wonderful tool, but be sure you use the technology; don't let it use you.

Fill Flash without TTL. There is a fairly easy way to accomplish fill-flash photos with manual flashes. Start by figuring your exposure as if you were taking a total flash photograph. Set the camera to the appropriate aperture. For example, if, with ISO 50 film and a 105mm lens, you would use an aperture of f/16, then set the aperture to f/16. Now determine your shutter speed as if you were taking a natural-light photograph. Let's say it's an early morning scene, and your subject is medium toned. You arrive at a shutter speed of 1/4 of a second at f/16. Set your camera for this exposure.

Now all you have to do is weaken the light source by two stops. You can do this in one of two easy ways. Using the inverse square law, you know that if you double the flash-to-subject distance, the light will weaken by two stops. So you could simply move your flash back behind the camera to double the normal distance. Or (and I think this is a more user-friendly solution), you can shop for plastic neutral-density filters or theatrical lighting gels, which come in stop increments. These can be cut down and taped or rubber-banded to your flash head to reduce the light. That's the simplest way to do it, and it doesn't require a flash stand, long flash cords, or anything else that would be easy to trip over in the field.

Where to Put the Flash

Where does light come from? It's so much a part of our lives, we may not notice that it's always coming from a particular direction. And the way things look depends a great deal on the direction of the light that is hitting them.

When I use flash, I most commonly put the flash in a position portrait photographers call "high basic"—disconnected from the camera body and mounted 30 degrees above the outer edge of the lens, pointed at the subject. This position provides a nice sense of depth to photos, good shadows, good *modeling* for perhaps 90 percent of my compositions.

But every so often you'll want to use the light to reveal texture, to reach into a burrow or nest, to illuminate translucent subjects. This is when it pays to have a very flexible, strong flash bracket, one that will allow you to move the flash as close to the axis of the lens as possible, or darned far away. To photograph into a burrow or cavity, you'll want the light very close so that it can shine down into the burrow and light the subject. A 30-degree angle wouldn't allow that photograph. To get it, you have to secure the flash almost on top of the lens.

More than One Light

In the field, especially with close-up work, I rarely use more than one good, versatile flash. It's difficult enough to focus and frame on small, active creatures with close-up equipment, without trying to add a second light source. But for every universal truth like this, there are situations that just demand another light source.

200mm macro lens with 1.4X multiplier, TTL electronic flash, flash compensation dial set at −2.0, 100-speed film, 8 sec., f/11, on tripod.
(Bittacus *sp.*)
Hanging motionless from vegetation in the dim light of a midsummer deciduous forest, hanging flies wait to dart out their hind legs after prey. They take smaller insects that fly by. Their habit of hanging away from background vegetation makes a total flash exposure undesirable for me; the distance would leave the background pitch black. But their stillness allowed me to combine natural light at a very long exposure with fill flash to make this portrait.

Although I try to keep my equipment as simple as possible, sometimes one light is just not enough. I was walking with an entomologist friend through my woodlot when we saw a number of gall midges hanging on the nonsticky support strands of webs made by filmy dome spiders. We wanted to photograph the behavior, but the woodlot was dark and the background distant. Without some extra equipment, we'd wind up with a black background. The next day, I placed the light stand holding a green card behind the web and mounted a second slave flash to light the card and provide a background.

When I need more light for close-up work, I mix small, inexpensive, easy-to-carry manual flashes with my TTL system. There are some nice slave flash units on the market. As long as your second light source is weaker than your main TTL flash, they're no problem to work with. A slave fires when its electronic sensor senses that the first flash has gone off.

My favorite use of two flashes is to put a rim of light around a subject by positioning a slave unit above, behind, and to one side of it, aimed at about a 45-degree angle. I photographed a katydid at night this way. The frontal light was in high basic position as the main light source. The only trick is making sure the second light doesn't flash into the camera's lens.

You can also use a second light source to illuminate a background that may be too far away to register properly. However many lights I use, I always try to design the lighting arrangement so that only one light comes from the front.

105mm macro lens with 4T close-up lens, 1.4X multiplier, and 52mm and 27.5mm extension tubes, 25-speed film, 1/250 sec., f/11, on tripod.
(Family Chironomidae)
I lit this gall midge composition with three flashes. One is mounted with the camera, providing front lighting. Another is mounted on a stand, lighting a background card. I held the third behind the web for backlighting.

When the Back Goes Black

Flash light is fast. It lights fast, and it falls off fast. So fast, in fact, that your daytime photos can easily look like they were taken at night.

Say, for instance, you expose a photograph of an insect sitting on a twig with some foliage 2 feet behind it. The insect is in profile. You use straight flash set to give you nice detail on the insect and the twig it's sitting on. But the light from the flash falls off quickly behind the plane of the subject, and the background foliage rec-

ords only as an inky black. The resulting photograph's not at all natural looking, unless you're photographing what is normally a nocturnal species.

It's really a problem of tonalities. Let's say that the camera is 11 inches from your subject and that those background leaves, instead of being 2 feet farther back, are only 16 inches from the camera, or 5 inches behind the insect. Your flash exposure is set so that a medium-tone object at the plane of the subject would be

105mm macro lens, TTL electronic flash on bracket in front and manual flash hand-held by assistant behind, 50-speed film, 1/250 sec., f/16, on tripod.
(Amblycorypha oblongifolia)
At midnight in a Michigan meadow, an oblong-winged katydid sounds its lisping chirps from the blossom of a black-eyed Susan. This is a two-light photograph. The front light is mounted on a flash bracket attached to my camera, while a friend holds a photo-cell-activated backlight. Without the backlight, the tiny antennae would have been lost in the background.

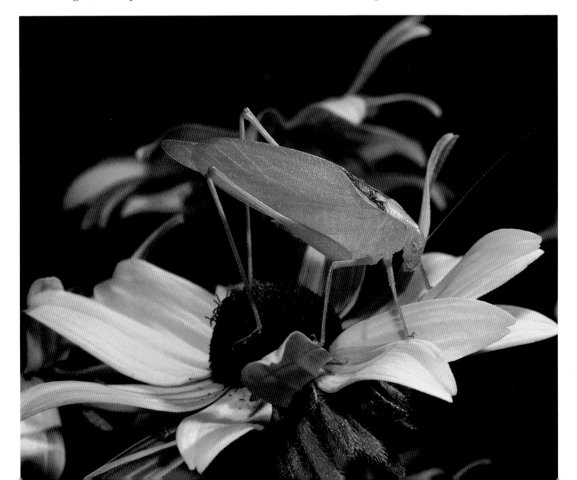

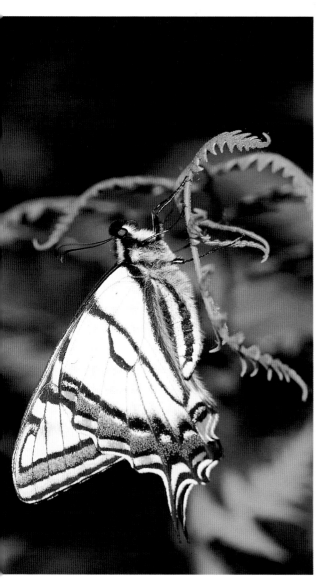 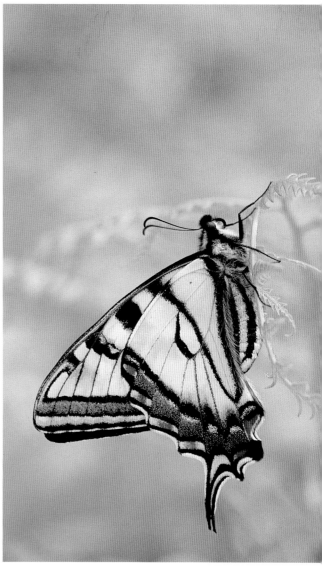

(Left) 200mm macro lens, TTL electronic flash, flash compensation dial set at + 0.3, 50-speed film, 1/250 sec., f/16, on tripod. (Right) 200mm macro lens, TTL electronic flash, flash compensation dial set at − 2.0, 50-speed film, 1/8 sec., f/16, on tripod.

(Pterourus canadensis)

My favorite multiple lighting uses the natural light as a main light and the flash as fill. For the photograph of the northern tiger swallowtail on the left, I used total flash, and the distant background goes to jet black. For the next photo, the natural light provides the main exposure for the background and foreground, while the weaker flash simply opens the foreground shadows and adds highlights.

recorded as a medium tone on the film. At half that distance, about 5 inches behind your subject, a medium-tone object would record as one stop darker than medium—in this case as dark green foliage. (Remember that light falls off at the square of the distance.) If the foliage were 22 inches away from the camera, it would drop to two stops darker, on the edge of black. Conversely, a medium-tone object placed 3 inches in front of the subject (which would be 8 inches from the camera) would appear a stop lighter on your slide.

If your background is too far away and you can't find another angle that works, or another subject, and it doesn't bother your artistic sensibilities, consider using a background card close to the subject, preferably in some natural color, that would allow you to at least take a record photo of the insect. Or if conditions permit, go to fill flash.

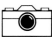
Photographing Insects, Spiders, and Their Kin

It's a Jungle Out There

No matter what sort of work we do, we have to spend a certain amount of time paying attention. We must watch trends and remain alert to whatever is developing just out of sight.

It's like that for me. I spend a lot of my time watching for changes and possibilities. Each day I try to spend at least a couple of hours wandering, watching, taking mental notes. Sometimes I find insects, sometimes I find clues about insects to come. But there's always something going on.

I find these things because I take the time to find them. I notice them because I've trained myself to notice them. Nature photography is all about training yourself to notice what's going on around you every day. It's good training for your work, for your family life, for living. And it stocks your store of terrific memories and wonderful photographs.

Paying attention to insects catapults you into a world you might have thought existed only in science-fiction novels. These creatures can restore mystery and challenge to even the most jaded person's life. Design, function, beauty—you are reminded constantly that there are worlds within our world that go on thriving, busy and bustling, whether we pay attention or not.

Choose to tune in. You can never waste your time when you're paying attention. To enjoy photographing insects, spiders, and the like, you need to know how, when, and where to approach them in a manner that is safe for you, the creatures, and the environment.

Low-Impact Photography

I said in the first pages of this book that I advocate a *low-impact* method of photography. There are many times I choose a *no-impact* approach. That is, I sometimes don't take the photograph because I know or feel the intrusion would cost too much. It would harm either the subject or its environment. The fact is, every time we take a step, we leave our mark. We are always making an impact, just as a raccoon does, or a deer, or a bird. If we're aware and intelligent about our approach to wildlands, our impact won't be any greater than that of any wild mammal.

Unfortunately, we're not always aware. Breeches of awareness abound and have given rise to a great deal of discussion and the call for a standard code of ethics among nature photographers.

In 1989, Jeff Foott, a well-known and well-regarded nature photographer, initiated a consciousness-raising forum for the discussion of ethics in *Outdoor Photography* magazine. It isn't the first of these discussions, but it's one of the most prominent. During the past few years, the concern has echoed through virtually every magazine and newsletter in the nature press.

105mm macro lens, 50-speed film, 1 sec., f/22, on tripod.
Backlit by the rising sun, spiderwebs cover a meadow along the northern shore of Lake Michigan.
Morning meadows are a wonderful place to look for the handiwork of spiders, and for sleeping
insects, naturally chilled and shimmering with dew.

Various photographic groups have published codes and guidelines of acceptable behaviors and etiquette for professional and hobbyist nature photographers. Our state and national parks contemplate regulations that would restrict photographers' activities.

I never would have dreamed thirty-five years ago, when I began my career, that the world would spend any time at all talking about nature photographers, much less worrying about what kind of impact we have on the environment or how well we get along with others who are trying to enjoy the same animals, views, and habitats. Thirty-five years ago, very few people were interested in nature photography. Today hundreds of thousands of hobbyists and professionals hit the nature preserves on weekends and all week long to photograph and enjoy wild creatures and wild places.

Unfortunately, some of them have muddled

200mm macro lens with 4T close-up lens and 2X multiplier, 50-speed film, 1/2 sec., f/11, on tripod.
In the time around dawn, insects and spiders, and the evidence of their work, become still-life
subjects for the camera. At this time, only the breezes move them. Here you can take your time,
contemplate, and carefully compose. I slow down. One subject can take me an entire morning.
Each detail holds meaning for me.

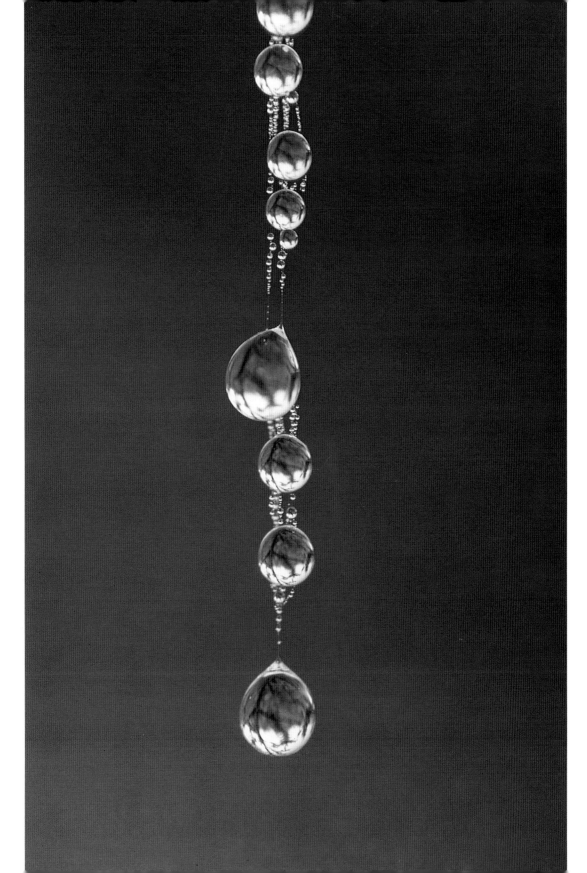

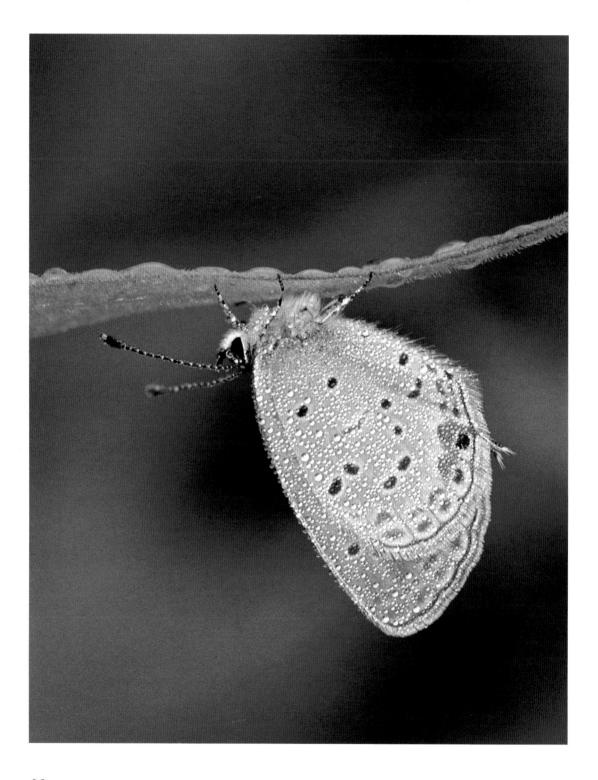

priorities. They've placed the importance of the photograph before the safety of the subject, and even before their own or other people's safety and enjoyment.

This discussion of ethics in photographing insects and spiders boils down to respecting their habitat. You don't generally have to worry about frightening insects so that they abandon their nests or young, or about attracting large predators toward them. Do worry about these things, however, with reptiles, birds, and mammals. With an insect, though you may startle a butterfly or bee to move from one flower to another while you're stalking, once you leave the area, it's going to pick up where it left off. I've observed that these interruptions don't seem to change the course of their lives.

With the common species, I encourage you to offer them simple respect, a little dignity. For this reason I don't go back to the same place day after day to make photographs. I give places a rest. And when I'm there, I'm conscious of where I put my feet, being careful not to disturb nests or vegetation any more than I have to. I avoid trampling an area, but go in for a little while, leave, and maybe visit the same place two or three times at most in a single season. Habitat preservation is where our ethics are going to be tested in insect photography.

With the common species, care is key. With endangered species, you have to take extra precautions. There are a number of endangered insect species living in such limited numbers in fragile habitats that I think we should just avoid photographing them at all, unless the photographs are needed for publicity to save these creatures. Endangered species, whether on public or private land, require a special permit before you can approach or photograph them. Chasing an endangered butterfly around, for example, without a special permit may constitute harassment, and you could be arrested for it. Check with a local biologist. Know what you're doing. If you don't know the species, avoid it.

Moving, Chilling, or Feeding Insects

Moving, chilling, or feeding insects is another ethically sticky area for nature photographers. Here's how I approach it. In my photography, I want to manipulate the world around me as little as possible to get as authentic a representation of my subjects and their behavior as possible. It's hard to contrive or fabricate authentic behavior.

When I first started photographing insects, I fell in love with jumping spiders. I wanted to photograph all the species of jumping spiders I could find. Well, jumping spiders constantly move around, and given the equipment of the day, it was extremely difficult to make photographs of these creatures. I read that if you fed spiders, you could photograph them while they ate the prey you'd provided. For a while I did this, and I've lived to regret it. For one thing, what do I know about exactly what a jumping spider eats? For another, who am I to decide the fate of the prey I've selected for my subject? The result is unnatural and probably inaccurate. I know it, even if no one else can tell.

Not long ago, while I was working in my backyard, I came upon a small jumping spider that had taken a leafhopper. This was one of the few times I actually was able to photograph

200mm macro lens with 3T close-up lens, 50-speed film, 1 sec., f/11, on tripod.
(Everes comyntas)
Eastern tailed blues are tiny butterflies (19 to 25mm) that range from southern Canada to Central America. Found in backyards, fields, and along roadsides, this is one of the most common butterflies in the East. This particular butterfly spent the night in a little meadow, clasping a sweet fern leaf. As the temperature dropped, dew condensed over its body, immobilizing it until sunrise.

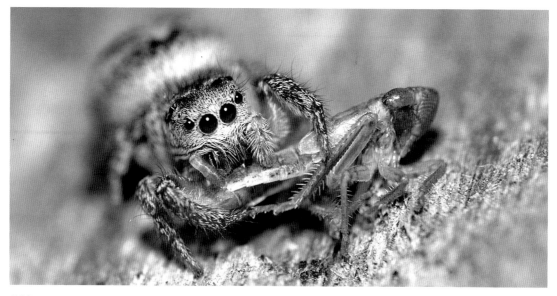

200mm macro lens with 4T and 3T close-up lenses and 2X multiplier, TTL electronic flash, camera compensation set at + 0.3, 50-speed film, 1/250 sec., f/22, on board pod.
(Habronattus viridipes)
Over the years, photographers have used many methods to subdue small, active creatures to take their portraits. Chilling, gassing, and feeding have all been used with varying degrees of success. They all will produce pictures, but not the pictures I want. My method requires a large investment of time. It requires waiting for interesting things to happen. Something interesting always does. This tiny jumping spider has captured a leaf hopper on the surface of my favorite log. I'm sure this happens quite often. This is the one time I happened to be there to see it.

an authentic kill made by a jumping spider. That photograph is vastly more valuable to me than all the contrived photos I made years ago.

Chilling insects falls into the same category for me as feeding them to get a photograph. By chilling, I mean taking an insect from the wild and putting it in a refrigerator or cooler or spraying it with CO_2 to slow it down and make it easier to photograph. You can't photograph natural behavior with a chilled insect. At best, you'll get a poor portrait; at worst, you'll kill the creature. Unless you're putting together some sort of scientific key and have to have pictures of immobilized living insects to illustrate it, I see no reason to do this.

I'm also seeing a lot of published pictures of insects in situations that make me doubt their authenticity. These are typically butterflies bejeweled with dew, sleeping on flowers where they've apparently spent the night. They're usually on beautiful, unblemished blossoms—situations I've never encountered in thousands

105mm macro lens with TC-14A multiplier, 50-speed film, 1/2 sec., f/11, on tripod.
Nature photography is not the art of producing a marketable image; it is simply the art of photographing nature. Butterflies rarely sleep on flowers. I have seen this behavior only once in my long career, yet the popular press is full of such images, making me question their authenticity and— much more importantly—the well-being of the subjects.

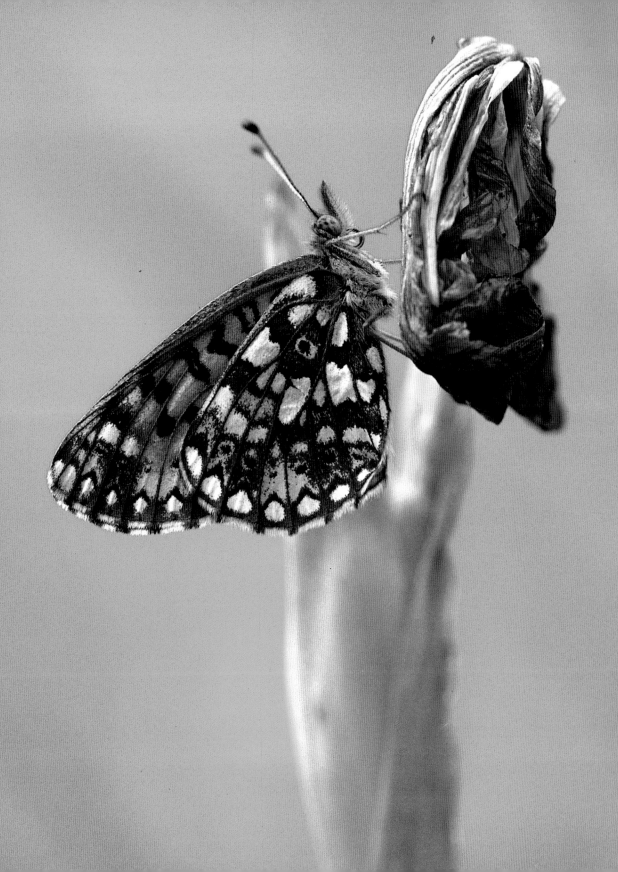

of mornings walking about looking for butterflies. I've found only one butterfly sleeping on a flower blossom in all my life. And it was on a wilted iris bloom.

I find photos of species I know spend the night hanging upside down under leaves in forest canopies photographed right side up on meadow grasses, covered with dew. This isn't a hard photograph to make. You find the butterfly sleeping at the end of the day and place it on the meadow grass to spend the night. Come back in the morning with your equipment, and you've got a beautiful, unauthentic photograph. As long as these photographers are simply trying to make beautiful still-life arrangements, I suppose it's okay. But when they pass these photos off as natural behavior, I consider their actions unethical.

The fun of pursuing insect and spider photographs lies in observing and recording authentic behavior, not contrived or fabricated situations. Authentic situations, where things happen spontaneously in front of the technology you've assembled, are exciting. When you let serendipity work, you never know what you'll encounter. It becomes a sport. You're challenged not by the drive to get every species of insect and spider on the planet on film, but by the drive to record what's happening constantly around you in meadows and fields and ponds.

Finding Subjects

If you're an entomologist, you already know where to find insects. If you're an arachnologist, you already know where to find spiders. If you're not either of these things, you may need to acquire some additional information to find the things you really want to photograph.

I like to study field guides and natural history

Low-impact photography means caring enough to be aware of the effect your photography has on your subject and its environment. I try to minimize the impact my presence has. I try to visit fragile ecosystems only for a few hours one day in a season, to avoid undue stress on the habitat.

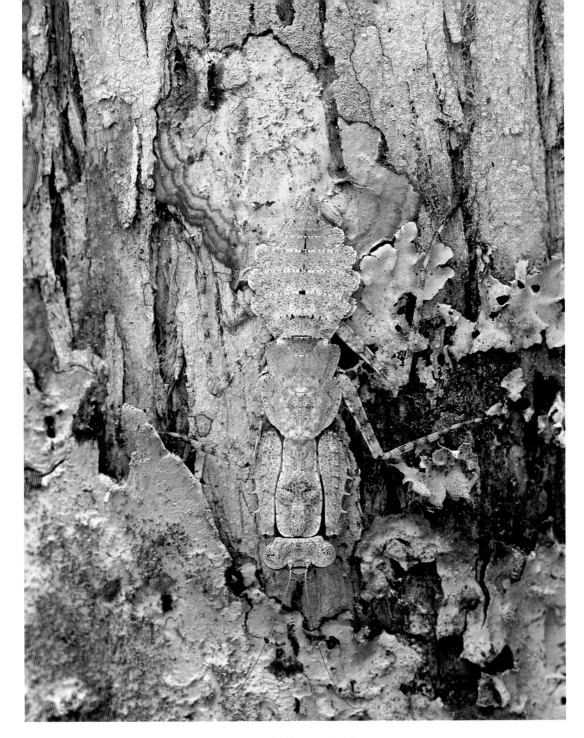

105mm macro lens, 25-speed film, 1/2 sec., f/11, on tripod.
(Gonatista grisea)
You see what you're ready to see. Amid blood lichens on the trunk of a bald cypress, in a south Florida swamp, a grizzled mantis relies on its protective coloration to help it blend. I found this subject while wading through a cypress slew in search of epiphytic orchids.

books as if they were wish books or catalogs. I go through them, looking for creatures I find especially attractive or interesting, and learn as much as I can about them. That way when I encounter them in the field, I can recognize them and predict their behavior. But you don't have to buy a library. A good field guide will send you on your way. I like *The Audubon Society Field Guide to North American Insects and Spiders*.

I use one of three approaches when looking for little creatures. The first I do daily, simply wandering into a familiar meadow, woods, swamp, or marsh near my house and aimlessly poking about, looking for nothing in particular. I always find something.

For this sort of work, I generally have a hand-holdable flash rig around my neck. And I just wander, photographing whatever I happen upon that day, whatever strikes my fancy.

My second method of finding subjects is a lot like the first but a bit more focused. This is when I head to a specific place where I know a lot will be going on. I keep an eye on any old

200mm macro lens with 3T close-up lens, TTL electronic flash, 50-speed film, 1/250 sec., f/22, hand-held.
(Epidemia epixanthe)
Bog copper butterflies are among the most specialized species I have ever recorded. They're found only in bogs, hence the common name, and then only in quaking *bogs where the larval food plant, cranberry, grows. Once you've located a bog with a bog copper colony, you must be there during late June or mid-July, because the butterfly only flies for two weeks after it emerges. If you're early or late, you simply will not see any sign of bog coppers in the places they live.*

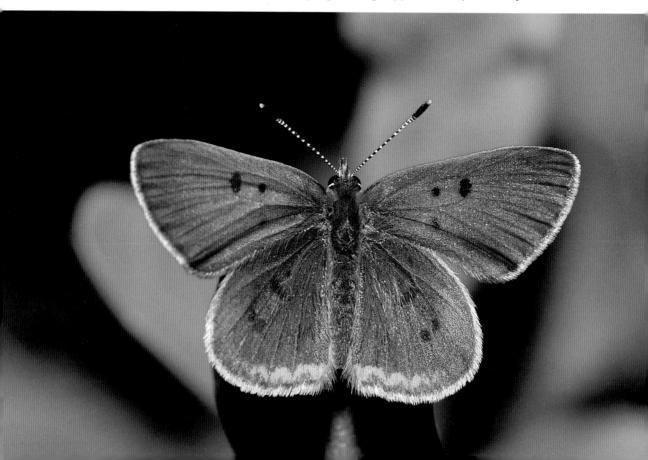

logs in the woods near my house. I like wet, sunny places, any place I know will be very productive. I keep track of good butterfly marshes and fields in bloom. And I may spend hours in one good place, possibly just exploring the length of an old log, recording the goings-on in that one small area.

The third method is highly focused. This is when I'm on a mission for a specific subject. I'm armed with lots of information before I head out. I can envision the whole situation, so I pack only the equipment I know I'll need.

For instance, I might be looking for a bog copper butterfly. This is a very small butterfly—so small you could almost cover this little creature with a nickel. If I were looking for a bog copper, I would first have to know what a quaking bog was and where to find one, because quaking bogs are where you find bog coppers. I would then have to know that not all quaking bogs have bog coppers. I would need to look for a bog that had growing in it the larval food plant of the bog copper—the cranberry. So I'd need to find a quaking bog that had cranberry—a cranberry bog. I'd have to learn to identify cranberry, too. Then I would need to know what specific time of year bog coppers fly. That happens to be the first couple of weeks of July in northern Michigan, where the cranberry bogs are.

Once I know all of this, it's a matter of packing the equipment I need and heading out there, properly dressed for a day in a bog.

I only occasionally go on these missions, for species that someone has requested from me or that have eluded me in my lifetime. I don't do it often, because I don't like that sort of goal-oriented approach. I like wandering. I like the serendipitous event. I like informed luck. The more I study insects, the more I know, the luckier I get. Because I see more.

Stalking Technique

I know this sounds funny, but stalking insects in the field is a very demanding, very physical activity. I stay in fairly good shape to do this

Having reliable, flexible equipment makes all the difference in the field. Here is West with one of his most common insect rigs. This setup allows him to work and move in dense vegetation with a 200mm macro lens and a powerful electronic flash unit. The saving grace is a special macro flash bracket, engineered for just the kind of close work required to photograph butterflies.

because I find myself contorting my body in very unnatural ways, getting up and down, walking at a half squat, crawling on my belly, standing on tiptoe for a good long time, and slogging through swamps in heavy hip waders or desert country in chaps. It's important to maintain your flexibility, your strength, and your endurance for fieldwork.

200mm macro lens with 3T close-up lens, TTL electronic flash, 50-speed film, 1/250th sec., f/16, hand-held.
(Neonympha mitchelli)
Recently added to the endangered species list, the Mitchell's marsh satyr butterfly lives in a very specialized habitat in southern Michigan and northern Indiana. In fens with an overstory of tamarack and an understory of poison sumac grow narrow-leaved Carex *sedges. This sedge is the larval food of the Mitchell's marsh satyr.*

I want a user-friendly equipment setup when I'm in the field. I've tried to recommend only user-friendly equipment so far in this book. When you get your equipment, play with it. Get comfortable with it. Your equipment should become familiar enough to you that you can concentrate on the insect or spider's behavior instead of on the technology. You need to pay enough attention to get the results you're after, but always keep your main attention on your subject. The equipment shouldn't be distracting.

I like to carry one camera body, one lens combination, one flash setup, and one tripod into the field for close-up work. I don't carry a camera bag, but I do pack a belt pack that's big enough to hold a couple of lens attachments. In it I might carry an extra diopter, a short extension tube, three or four rolls of film, a couple of clothespins for temporarily pinning leaves out

of the way, and a small Swiss army knife. I leave the rest of my equipment locked in my car or at home so I don't have to be burdened with a camera bag.

When I've found a subject, say a Mitchell's marsh satyr butterfly, I preselect my exposure controls, setting the shutter speed I know I'll need and choosing the aperture based on the available light. If I'm working in total flash, I set both the aperture and the compensation dial.

You'll discover that when working in high magnifications, just finding the subject in the viewfinder is challenging enough. For really small insects, I still have trouble doing this, so I don't want to be fussing with setting the exposure once I've found my subject. It's just too hard to look away and then recompose. And the insect may no longer be there when you look back.

With the exposure set, it's just a matter of physically getting into position to make the picture. My every movement has to be slow and smooth. I'm going to try to maneuver so that the film plane is parallel to the plane of the butterfly. I'm likely to be moving through waist-deep sedges for this species, and the butterfly

200mm macro lens with 4T close-up lens and 2X multiplier, TTL electronic flash, 50-speed film, 1/250 sec., f/16, on tripod.
(Family Membracidae)
Often I'll choose an area because of its potential for nice, evenly toned backgrounds. I like broad leaves like that of the common milkweed, wild grape, or basswood. I like sand dunes, or surfaces of logs and trees—surfaces large enough to completely frame my subject and simplify composition. Small creatures are so numerous that if I hang around long enough, something interesting is bound to show up, like this treehopper.

200mm macro lens with 4T close-up lens and 2X multiplier, TTL electronic flash, camera compensation dial set at + 0.3, 50-speed film, 1/250 sec., f/16, on tripod.
(Family Muscidae)
Some species of mushrooms are sure to yield interesting insects. Others draw nothing. This mushroom, Amanita vaginata, *is a favorite for several kinds of muscoid flies, forest relatives of the familiar housefly. Mushroom caps make great backgrounds. I either stalk from mushroom to mushroom with a tripod-mounted setup or set my equipment within range of a likely looking cap and wait for something to arrive.*

106

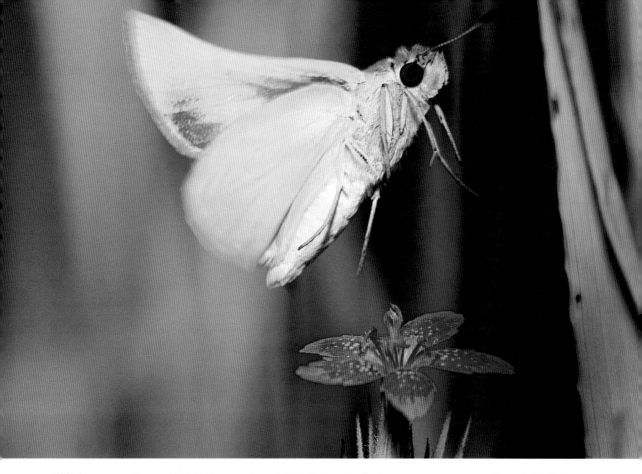

200mm macro lens with 3T close-up lens, TTL electronic flash, camera compensation dial set at + 0.3, 50-speed film, 1/250 sec., f/22, hand-held.
(Atrytone delaware)
Sometimes you get lucky. Just as I released my shutter, this Delaware skipper butterfly left the Deptford pink blossom, stopped in its ascent by the wink of the flash.

will be down in and completely surrounded by sedges. So, very gently, I'll part the sedges and sort of fold them apart without breaking them so they'll stay in place while I move my camera into position.

Once I can get close enough, bring my camera to my face, and find the butterfly in the viewfinder, I must work the lens from side to side to find the best plane to increase the depth of field and get as much of the butterfly in focus as possible. I then work forward or back to find the best composition, and I begin moving my body to increase support. Generally this means I'm halfway down in the sedges, with my el-

bows resting on the tops of my knees and my head down. When I get everything where I want it, I gently squeeze the shutter release, the flash fires, and I've made a photograph. I'll probably make several exposures, because I've worked hard for this and would like a number of original frames.

This triangular pose is one I've found to be most stable for taking hand-held photographs. The classic pose is when I've gotten down on both knees, and I'm shifted to one side with one or the other elbow braced against a knee, leaning forward. This is a nice, stable position. Or if there is a nearby stump or tree, I'll lean myself

and my camera against it, always looking for the most stability in any situation.

Now, I just walked you through a fair description of how stalking works in the field, but I left out one fairly important detail. That Mitchell's marsh satyr probably flew away eight or fifteen times before I got close enough to take a photograph. Stalking requires patience, grace, a willingness to persevere, and the ability to let a subject go if it wants to. Keep in mind the law of averages: The more you go out and work at stalking, the more photos you'll get. The less you work at it, the more frustrating it will be when the butterflies fly away.

Insects in Action

Because of the small size and rapid movements of insects in motion, most such photographs have been made under very controlled conditions. The definitive work in this sort of photography was accomplished by British photographer Stephen Dalton and is recorded in his book *Borne on the Wind.* My flight photographs have been the result of serendipitous events—the insect flew just as I released the shutter, and somehow everything ended up in proper focus.

There are, however, many small moving creatures that can be photographed in the field with conventional TTL flashes. Insects with prey, insects leaving or entering nests or burrows, spiders spinning webs or swaddling prey, even large, hovering dragonflies can occasionally be recorded on film. Mastering your flash equipment and learning to pan with a magnified view of the world are the great challenges for an action photographer.

Packing for Fieldwork

Most people who take up nature photography already have some experience with outdoor hobbies and understand that when you're enjoying the outdoors, it helps to be prepared for any find, any event, any weather.

200mm macro lens with 3T close-up lens and 2X multiplier, TTL electronic flash, camera compensation dial set at + 1.0, 50-speed film, 1/250 sec., f/16, on board pod.
(Bicyrtes sp.)
The rapid blink of a flash captures the stinkbug catcher wasp gripping an immature stinkbug with her middle legs. Using her front and back legs, she scrapes open the entrance and enters her well-concealed burrow. The whole process takes less than a minute.

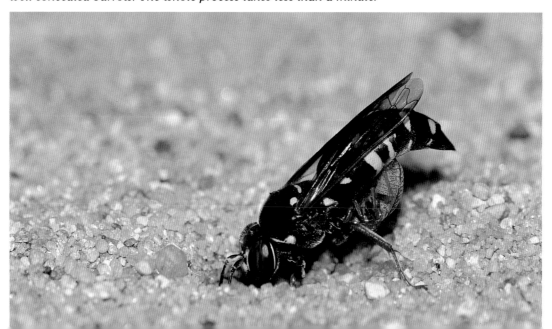

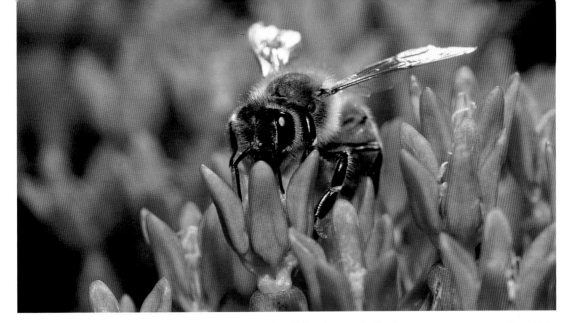

105mm macro lens with 52.5mm extension tube, TTL electronic flash, camera compensation dial set at + 1.0, manual flash backlight, 50-speed film, 1/250 sec., f/16, hand-held.
(Apis mellifera)
Hand-holding a camera with TTL electronic flash allows me to photograph animated subjects like this foraging worker honeybee as it moves from flower to flower. A friend holds a slave-activated backlight, giving an almost studio quality to the light.

The best way to be prepared is by preparing your mind. Know something about your destination. Be aware of poisonous plants, stinging insects and their habitats, which animals are approachable and which aren't. In nature preserves and sanctuaries, mind all posted signs. They were placed there by someone with a good reason to post a sign, and photographers should take it upon themselves to lead by example, not bend the rules.

Some things that might be helpful to have when photographing all day in an unfamiliar area include a compass, twist-ties, a pocket-knife, a good bit of twine, organic deterrent spray, a small first-aid kit, batteries, film, film, film, and plastic bags and cloths for keeping your equipment clean and dry.

Clothes and Comfort

I dress right when I'm in the field. I dress for maximum comfort and safety. If it's a dewy, early morning, or if I'm crawling around in the

I seem to spend a great deal of my time on my hands and knees. On warmish winter days, when a few species of insects and spiders are out, I'm out, too. I dress to keep warm and dry, and use my board pod to provide sturdy support and keep my equipment out of the snow.

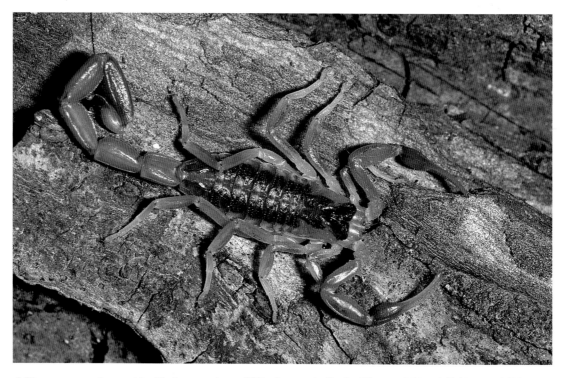

200mm macro lens with 4T close-up lens, TTL electronic flash, 50-speed film, 1/250 sec., f/22, on tripod.
(Centruroides *sp.*)
I like scorpions, such as this bark scorpion. But I like them where I can see them. Some species are very poisonous and can bring death. All of them have stings that hurt a lot. Working in the field, I'm careful where I put my hands and feet. I make a real effort not to let my enthusiasm get me into trouble. Prevention is always the best medicine.

snow looking for winter insects, I like to wear waterproof boots, something with Gore-Tex and Thinsulate so my feet are light enough to pick up, flexible enough to walk on uneven terrain, but still warm and dry. I also wear Gore-Tex rain pants when I'm crawling around in the snow or am out on cool, dewy, or frosty mornings. The more comfortable I am, the longer I'll stay out and the more I'll see.

When I work in water, unless it's a 95° August day, I'll stay warm and dry in chest-high waders. Wherever I find thorny plants or biting snakes, I wear a pair of snake chaps made of thick nylon that can resist the strike of any North American snake and turn away brambles, briers, and cactus spines. They're a little stiff to walk in and cost a few extra calories each hour, but they're well worth the trouble.

I also dress to avoid insect bites. I'm careful to avoid tick bites and bee stings, always keeping alert for ground-nesting bees and wasps, especially when I'm covering new ground. I don't mind sweating all day or getting mud in my shoes or soggy all over, but snakebite, bee stings, or Lyme disease would ruin a good time. So I'm as careful as possible.

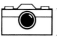
Making a Good Photo Great

Persistence

Oftentimes it is not enough to go into the field, find a subject, approach it, and take its picture. It may be a wonderful subject but a crummy situation. When I find a butterfly I like, I will follow it for as long as I can stay with it, photographing it in as many situations as I possibly can. I want to see it in different settings, with different backgrounds, with different colors around it. I want to explore the relationship between its size and its background. I want horizontal and vertical compositions, with wingspans and folded wings. Persistence and a good eye make the difference between good pictures and great pictures in insect and spider photography. The longer you stay with a subject, the better the chance that you'll put something really meaningful on film, aesthetically, behaviorally, or both.

Really, whenever you make a photograph, you're selecting a moment in time and space and isolating it in a frame. You're plucking from reality, refining it, simplifying it, and presenting it on film. When you understand this, you begin to see in a different way. You see that a wing pattern, an empty cocoon, even web strands have their places as interesting photographic subjects.

Good light helps. I like to work in the rarer light—earlier or later in the day, in fog, under overcast skies, when the sun breaks through a very dark sky, sunrise, sunset, the light at the edge of a storm—light that offers drama. Insects are harder to find but a whole lot easier to photograph at these times. And it's just a nice time to be outside. When you feel good and alive and are breathing fresh air, you're much more likely to find good things to photograph.

Rare species are terrific subjects, but any old bug will make a great subject. It just needs its moment. It needs its best light, the best composition, its best season. If you can capture a housefly at its best, you'll have a great photograph.

Knowing Your Subject

The sheet-web wolf spider belongs to the genus *Sosippus*. The sosippus wolf spiders are the only wolf spiders that use silk in the capture of their prey. Whereas other wolf spiders tend to run down their prey, sheet-web wolves developed in parallel to the true sheet-web weavers, the Agelenidae. My friend Mike Kirk found this spider while we were visiting in Texas. The spider had spun a special layer of heavier silk, on which she is now laying her eggs. As soon as she has laid her eggs, she'll cut the silk and swaddle the eggs to make a spherical egg sac. She then will attach the egg sac to her spinnerets and drag it behind in the protective manner that all wolf spiders have.

Mike found the unusual spider engaged in this very usual behavior. And we were lucky enough to get it on film. We might have overlooked the whole episode if I hadn't read about sheet-web wolf spiders—in fact, if I hadn't grown up reading and rereading *American Spiders* by Willis Gertsch. Gertsch's book described the lifestyles and habits of many North American spiders. And for me it was magical.

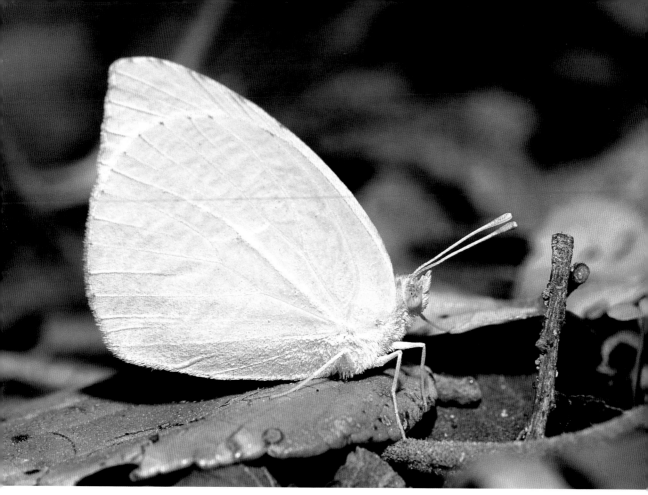

200mm macro lens with 3T close-up, TTL electronic flash, camera compensation dial set at + 0.3, 50-speed film, 1/250 sec., f/22, hand-held.
Guayacan sulfur (Kricogonia lyside).

Without reading and daydreaming about finding this spider, I might not have recognized it as special. I would not have known this spider's habits, its biology, its *thusness*. When I learn about insects, I want to know a lot of things about them. I want to know what they look like throughout their life cycles. I'd like to know when they hatch, how long they live, when and how they breed. What and when do they eat? What eats them? How do they find their food? Where do they go in the winter?

When I have an opportunity like I did with the sheet-web wolf spider, I can't help but think how many fabulous photo opportunities I've missed because I don't know all there is to know about everything. That sends me back to the library for more books.

Focusing Your Attention

Probably the most important element of this whole process of photographing small creatures, or photographing anything, for that matter, is understanding how we program ourselves to see, to perceive the things we want to photograph. When you're photographing moose, you likely won't have trouble picking a moose out in a field. But when you're working with really tiny creatures, and with lines and

patterns and graphics, learning to focus your attention and really perceive your subjects is much more difficult and terribly important.

The apparatus that forms human vision takes in an enormous amount of information. Very little of what our eyes take in breaks through into our conscious thought. On a walk through the woods, a grizzly bear will break through, but a mite on a lichen on the shady side of a log won't unless you're tuned in to it.

When I go out photographing insects, I think only about insects. I enter the insect dimen-sion, and eat, sleep, and drink insects. I read about them by night and look for them by day. I was in a butterfly dimension when I came upon the American copper on page 114. To my knowledge, it was the only butterfly sleeping in a half-acre meadow one morning. And I saw this butterfly from 30 feet away sitting on the top of this weed. It's smaller than a quarter, but I had that butterfly part of my brain tuned in, my attention focused clearly on little winged things, and somehow I saw it.

Focusing your attention also means being

105mm macro lens, TTL electronic flash, flash compensation dial set at + 0.3, 50-speed film, 1/250 sec., f/16, hand-held.
Sheet web wolf spider (Sosippus *sp.*).

113

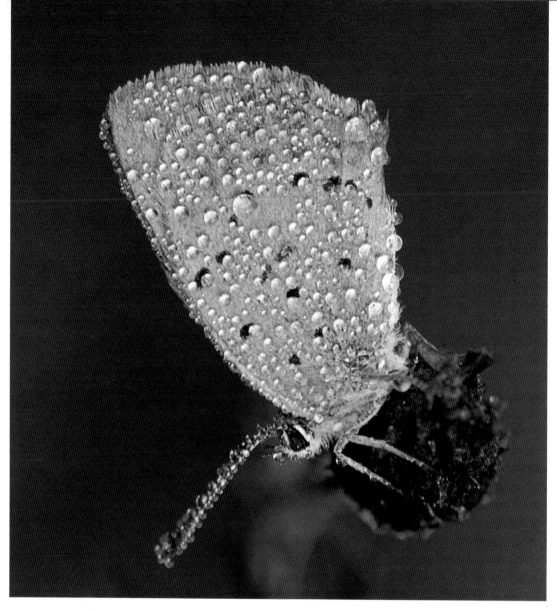

200mm macro lens with 3T close-up lens and 1.4X multiplier, 50-speed film, 1/2 sec., f/11, on tripod.
American copper (Lycaena phlaeas).

ready for great behaviors. You can't take photographs of great moments unless you're behind the camera, ready, when they happen. You have to be ready for the decisive moment, when everything within the picture comes together. The pose, the lighting, everything. This may be one brief moment, when the insect devours its prey or preens, and the action just makes the photograph. Or it may be when one ray of light breaks through the clouds and lights the water droplets on a beetle's back. It's when the foreground and background all of a sudden make sense, when your composition is just so. It's when everything is right.

105mm macro lens, 50-speed film, 1 sec., f/16, on tripod.
Luna moth (Actias luna).

Composition Primer

I generally feel that a perfectly balanced composition is less interesting than a dynamically imbalanced composition—off-center framing.

There's an old artistic principle of composition called the "rule of thirds." If you mentally divide your photo area into thirds horizontally and vertically (imagine a tic-tac-toe grid placed over your viewfinder) and place the main subject on one of the inside intersection lines, you'll have a composition that lives by the rule. And eight times out of ten, it will be more interesting and more informative than an on-center composition. An easier way of interpreting this rule is that placing the subject somewhere off-center is usually a good idea, though at times you may want the peace and tranquillity, the quiet of a centered composition. It depends on what you're trying to achieve.

It's a fairly safe rule but a little too tidy for me. I think that the right composition should suggest itself to you. These are your photographs, and they should express what you want them to. So when you compose a photograph, really look at it. Take different kinds of photographs. Try framing your subject in different ways, horizontally and vertically. Place yourself at different angles. Notice what sort of graphic pattern the background makes. What do the colors do in the scene? What sorts of shapes do you see? Which way do the lines move? What is the insect facing? Is it obviously moving in one direction or another?

For every photo, you'll start from scratch with these considerations. When you are fairly well settled on a composition, be sure to check all the edges of the frame. It's easy to keep your eye on the subject and forget that you may have a blade of grass sneaking into one corner of the frame.

Individual tastes vary, of course, but it's almost always true that a simpler composition is more successful than a complicated one. With my close-up photos, I try to let the insects and spiders and their behavior tell the story. I try to keep the backgrounds simple, the lines clear. The insects get center stage, holding our attention at least for a little while.

RESOURCES

Magazines

Nature Photographer
P.O. Box 2037
West Palm Beach, FL 33402
407-586-7332

Outdoor Photographer
12121 Wilshire Blvd., Suite 1220
Los Angeles, CA 90025-1175
310-820-1500

Outdoor Travel and Photography
1115 Broadway
New York, NY 10010

Popular Photography
1633 Broadway
New York, NY 10019

Articles

Burian, Peter K. "Multi-Segment Metering." *Outdoor Photographer*, September 1990.

Carroll, Ron. "Remotes & Slaves." *Outdoor Photographer*, July 1987.

"Electronic Flash." *Photographic*, June 1990.

Foott, Jeff. "Ethical Photography: Sharing the National Parks." *Outdoor Photographer*, February 1989.

———. "On Ethics in Photography." *Outdoor Photographer*, November 1988.

Jones, Dewitt. "Brainy Strobe." *Outdoor Photographer*, February 1989.

Leach, Ron. "Do-It-All Lenses." *Outdoor Photographer*, August 1990.

Lepp, George. "Ballheads!" *Outdoor Photographer*, March 1991.

———. "Tele-extension." *Outdoor Photographer*, March 1992.

Longest-Slaughter, Helen. "An Interview with Larry West." *Nature Photographer*, September/October 1991.

———. "Ground-Nesting Solitary Wasps" (an interview with Larry West). *Nature Photographer*, July/August 1992.

———. "Larry West's Winter Insects." *Nature Photographer*, January/February 1992.

Peterson, B. "Moose." "Nature." *Popular Photography*, January 1992.

Picker, Fred. "Zone System Made Easy." *Outdoor Photographer*, September 1989.

Rowell, Galen. "The New Fill Shooters." *Outdoor Photographer*, May 1990.

West, Larry. "Exposure-wise: De-mystifying Metering." *Birder's World,* July/August 1988.

Books

Dalton, Stephen. *Borne on the Wind.* Reader's Digest Press, distributed by E.P. Dutton and Co.

Gertsch, Willis J. *American Spiders.* Van Nostrand Co., 1949.

Lepp, George B. *Beyond the Basics.* Lepp and Associates, 1993.

Line, Milne, and Milne. *The Audubon Society Book of Insects.* Harry N. Abrams, 1983.

Milne and Milne. *The Audubon Society Field Guide to North American Insects and Spiders.* Knopf, 1980.

Shaw, John. *Close-ups in Nature.* Amphoto, 1987.

———. *The Nature Photographer's Complete Guide to Professional Field Techniques.* Amphoto, 1984.

Stokes, Donald, and Lillian Stokes. *Stokes Nature Guides.* Little, Brown and Company.

Nature Photography Equipment

Mike Kirk Photography
RR #4 Box 158
Angola, IN 46703
219-665-3670

Leonard Rue Enterprises
138 Millbrook Rd.
Blairstown, NJ 07825

Century Precision Optics
10713 Burbank Blvd.
North Hollywood, CA 91601
800-228-1254